DeGARTHE

HIS LIFE, MARINE ART AND SCULPTURE

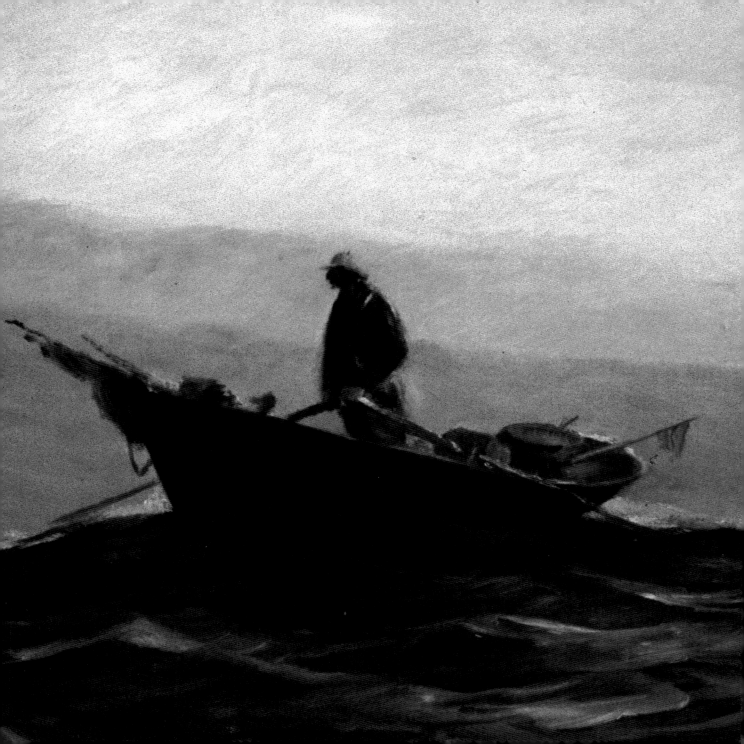

DeGARTHE

HIS LIFE, MARINE ART AND SCULPTURE

DOUGLAS POPE

LANCELOT PRESS
HANTSPORT, NOVA SCOTIA

ISBN 0-88999-397-1

BOOK DESIGN by Robert Pope and Joan Sinclair

COLOR PHOTOGRAPHS by George Georgakakos

FRONT COVER: detail from *Morning Mist*, by deGarthe
Collection of the Art Gallery of Saint Mary's University.

FRONTISPIECE: detail from *Looking for the Mothership* by
deGarthe. Collection of the Public Archives of Nova Scotia

Published 1989
 Second printing September 1989
 Third printing June 1994

LANCELOT PRESS LIMITED, Hantsport, Nova Scotia.
Office and production facilities situated on Highway No. 1,
1/2 mile east of Hantsport.

MAILING ADDRESS:
P.O. Box 425, Hantsport, N.S. B0P 1P0

ACKNOWLEDGEMENT: This book has been published
with the assistance of the Nova Scotia Department of
Tourism and Culture.

Contents

Acknowledgements

One of the pleasures of writing this book was the opportunity it afforded me of making the acquaintance of Mrs. Agnes deGarthe. She weathered incessant inquiries and went out of her way to make available to me an assortment of her husband's work—paintings, sculptures, drawings, letters and photographs. For her patience, cooperation and advice my deepest thanks and appreciation. To her nephew, Tom Degerstedt of Finland, who performed a similar task on the research end and who I fear was stung with some costly telephone and postage bills, my added thanks.

To those companies and individuals who are the proud owners of deGarthe paintings and who allowed me access to view and photograph these works, my thanks. They include: Agnes deGarthe, the Public Archives of Nova Scotia, Nova Scotia Light and Power Corporation, the Art Gallery of Nova Scotia, the Art Gallery of Saint Mary's University, the Art Gallery of Dalhousie University, the Royal Bank, the Canadian Imperial Bank of Commerce, the Halifax Insurance Company, St. John's Anglican Church, Peggy's Cove, Mr. and Mrs. Jack Campbell, Marjorie Ross and Mr. and Mrs. William Pope.

Many individuals kindly consented to interviews for this book. They are: Agnes deGarthe, Tom Degerstedt, Robert Chambers, Marguerite Zwicker, René Barrette, Mr. and Mrs. Donald Crooks, Ned Norwood, Bill Norwood, Helen Beals, Ian Muncaster, David Whitzman, Anthony Law, Margaret Pope, Mr. and Mrs. Roger Crooks, Rev. Lloyd Ripley, Jack Campbell, Gertrude Crooks, Francis Garrison, Keith Cleveland, Roosevelt Hubley, Ron Wallace, François Delisle,

Lorna Inness, Victor Steele, Doris Saunders-Hynes, Charles Longley, Mr. and Mrs. Malcolm Carmichael, Isabel Pope, William Pope, Robert Manuge, Ardith Sievert, Harold Kearns and Lou Collins. To all, my sincere thanks.

Photographs were supplied by and appear courtesy of Ned Norwood, Nova Scotia Government Information Services, the Public Archives of Nova Scotia, Wambolt-Waterfield, the Halifax Herald, Margaret Pope, François Delisle, Doris Saunders-Hynes, Agnes deGarthe and Tom Degerstedt. My thanks to all for their help and cooperation.

Quotes from newspapers appear courtesy of the *Halifax Herald.*

For assistance with research my thanks go out to the reference staff of the Halifax Public Library, the staff of the Public Archives of Nova Scotia, to the Dalhousie University Archives, the Art Gallery of Nova Scotia and to the city administration of Kaskö, Finland. For their personal assistance I thank Maurice MacDonald, Margaret Campbell, Judy Dietz, Leighton Davis and Owen Carrigan.

A special thank you is extended to Mr. and Mrs. David Brekke for the translation of letters, along with related discussions, and to Janet Pope for her suggestions concerning the legend of Peggy's Cove. I appreciate short talks with Helen Creighton and Clary Croft for their helpful words on the same.

To my father and mother, for their advice and support throughout, a kind thank you.

To George Georgakakos and David Middleton, who shot the colour photographs, my thanks for a job well done.

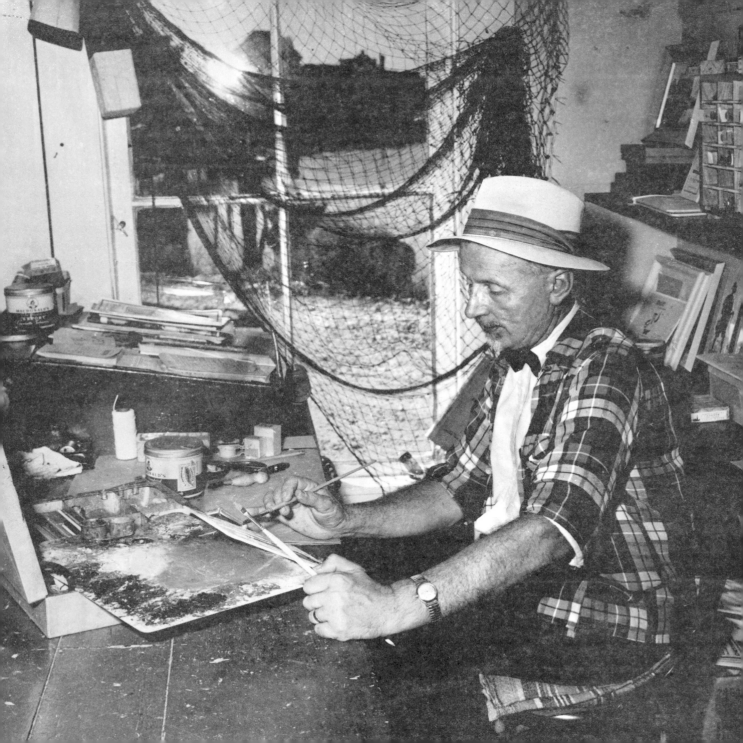

1 Wanderlust

William Edward deGarthe left his native Finland at the age of 19 in search of romance, adventure and to find, in his own words, "the most beautiful spot on earth." He was eager to discover new experiences, but he was also convinced that success is achieved through hard work.

He became the resident artist of Peggy's Cove, as he is perhaps best remembered. Here he met and talked with thousands of people: reporters and tourists, the connoisseurs and the mildly curious. He spoke eloquently of his love for the sea and his love for art. Today, though the man is gone, his voice continues to impress us through his many romantic paintings and heroic sculptures. These point backwards to an era of proud seafaring men and to the existence of an elemental world in harmony with itself.

To the end of his life, deGarthe's face retained its boyish quality—the proud, inquisitive eyes creating a fan of wrinkles when he smiled, the dimpled cheeks, the knowing, bemused grin and the famous whitish tufts of a Van Dyke beard set off against a sunburnt face.

The artist in his studio.
Photo by Wambolt-Waterfield.

He exuded confidence, crowning his six foot frame with a variety of berets, fedoras and elegant panama hats. People remarked that *he looked like an artist*—one writer called him "the father-custodian of the dignity of his profession"—in his habitual bow tie and plaid working shirts, though he was equally at home in a tuxedo. His dress reflected the alternate sides of a complex nature: showman and worker, actor and artist.

deGarthe loved people and for most of his life was surrounded by friends. He had a wonderful sense of humour and was not above pulling a greenhorn's leg. Often when he spoke, there would be a wink to a knowing observer. An aquaintance remarked that deGarthe lived in Canada for over 50 years and that, far from losing his Scandinavian accent, it seemed to get a little stronger every year.

On his introduction to the Queen during her Halifax visit in the mid-seventies, deGarthe was at his effusive best. Knowing the Queen had been staying on her private yacht, he commented about the weather: "When we heard it was rough outside, we were worried about your Majesty." One friend thought he was going to pat her on the head. No one took offense, however, and his remark opened up a long, animated conversation with Prince Phillip. As they walked away from the official party, the two discussed art with the topic turning inevitably to Phillip's extensive collection. Learning he owned no deGarthes, the artist set out to remedy the situation. "Had I known I would have brought you one," he said. Phillip answered: "Please don't make it too small," for once outjesting the smiling extrovert. This story was related by deGarthe himself—he loved a joke, even at his own expense.

He was like a divine clown, releasing the world of troublesome inhibitions. But it was more than just humour that made him the centre and dominant figure of any group. At an expensive restaurant with a gathering of friends, the maître

d' would defer to him, offering him the menu first and choosing him to select the wine. And he would make quite a production of it. He was playing a part and he played it exquisitely.

People opened up to him, telling him things they might not tell their dearest confidants. Bob Chambers, noted Halifax cartoonist and long-time friend, confirms this: "He was the sort of fellow you could tell your troubles to, he'd listen to you and give you advice. You found you told him things that you wouldn't normally do because you knew he was sympathetic. He knows more about me than . . . I hope he took it all with him to the grave—the things he knows about me!"

Hard working, deGarthe bubbled with enthusiasm and this enthusiasm rubbed off on others. He enjoyed life and people liked to be around him. Margaret Campbell, an archivist, called him "utterly charming and delightful." After a business transaction, he treated her and an associate to lunch, at which "all we could see was deGarthe." His high public profile was something that came naturally to him.

But this is just one side of a man famous for taking long, solitary walks along the shore. He might pick up interesting bits of driftwood or gaze fondly out to sea, happy to be outdoors and enjoying nature. A neighbour of many years told me: "In his own way he was a loner. He was a wonderful personality, very outgoing. He loved to talk to people and to meet people, but you sensed he was very private. He was a showman. He entertained you, but he didn't confide in you. He wasn't interested in petty gossip, he wasn't a gossiper."

It was this combination of exuberance and interest in people, with a reserve when it came to private details, that made the man trustworthy. Gertrude Crooks, the former postmistress of Peggy's Cove, told me: "If he said something, you knew he meant it." By the same token, he expected others to be honest and straightforward with him. Even in a friendly hand of bridge, there was a scrupulous sense of gamemanship. Careless players were warned: "We play by the rules."

One of the most commonly reproduced pictures of deGarthe, it shows him in the attire in which he liked to paint: beret, bow tie and plaid working shirt.

deGarthe points out features of the cove to an unidentified visitor. Photo by Robert Norwood

Once an opposing player became frustrated and cried out that, because he was not so skillful as the deGarthes were, mistakes on his part were inevitable. Skillful or not, Mrs. deGarthe said, he should not bend the rules of the game. The next day the poor player regretted his outburst and apologized. deGarthe, defending his wife, said he was right to apologize. Earlier this same man had approached deGarthe about getting a ride with him into town each day. He was told: "I don't like to be tied down. If you ride with me, you do it on my terms." deGarthe was very punctual and expected as much from others. He had high standards and insisted that things be done right. When they weren't, he was not afraid to speak his mind.

"You didn't have to know him long before you were impressed," Malcolm Carmichael, a long-time friend, told me. He described a man who warmed to you slowly, but once he did, was a staunch and loyal friend. He had an air of maturity and purpose to him, and he was a terrific worker.

Neighbours wondered how he accomplished all that he did. "He would always stop and talk with us," a fellow villager said, "but you sensed he didn't have time for small talk, that he had important things to do."

When I approached Donald Crooks, a neighbour who helped deGarthe with his ambitious monument, he said: "He died too young! That sounds strange — he died when he was what — 75; you had the impression he would just keep going. You never thought of him as old."

It was this same quality that prompted reporter Lorna Inness to write of him: "This ageless man, with an appreciation for life and a zest for living that would shame many in their early 20s, feels a keen sense of the responsibility that goes with talent. 'This gift has been given and it has to be given also in turn,' the artist says. 'One has to give that talent or the benefit of it to others, otherwise the gift becomes stale. You cannot isolate yourself from the world. You have to go into the world to renew yourself.' "

deGarthe continually reached into the world, making contact with an extraordinary number and range of people. The association might be professional, it might be personal, often it was both. A former student of deGarthe's, René Barrette, became a close friend. He learned to value the human qualities of deGarthe over and above his artistic merits:

> At the time I met Bill, he was wealthy, well established, generally respected and appreciated for his talent. He had a way of dealing with people of all walks of life in which he imparted an interest in them and a genuine *joie de vivre.* Everything he did, such as having a good fish dinner (of which he had many), was relished, discussed and fully appreciated. A short walk from his home to the Sou' Wester Restaurant was an expedition of delightful things to see—the light on the fog bank, a wave breaking over a rock—yet he had taken that same walk thousands of times. What a wonderful way to live—to get so much out of life!

Articles on deGarthe and his work have appeared in countless newspapers and magazines in Nova Scotia, New Brunswick, Western Canada, Boston, New York and Florida. He was an irresistible subject for the press and they eagerly sought him out. He was always willing to cooperate.

But though the press was one of deGarthe's strongest and most constant allies, they could not shield him from inevitable controversy. A tireless promoter of his own activities, he's been described as having an ego the size of Nova Scotia and as being a commercial artist—or an artist who painted for tourists—with a very high rate of production. Art critics have largely ignored his work.

Nonetheless, paintings by deGarthe have found their way into the offices and halls of universities, the boardrooms of banks, insurance companies, embassies and other government institutions; as well as the homes of thousands of private

individuals, art galleries and archives. One painting is mounted on the wall of an outport church in Newfoundland; others can be seen anywhere from Japan to Scandinavia to Africa. deGarthe's fishermen's monument, which serves also as his tomb, is viewed by as many as 200,000 people a year.

"Do you know how long that monument of his will last?" David Whitzman asked me. "As long as the rock keeps standing in Peggy's Cove," he said. "Unless there's an earthquake, that'll be around in 800 years and as long as it does, people will remember deGarthe. Do you know how long the politicians and others on the scene will last? They will all be forgotten, but deGarthe will last because of that stone."

Whatever medium he worked in, deGarthe reached out to a wide public and stirred them with his romantic vision. He was a natural communicator with a flair for dealing with people. But more than anything else he will be remembered for his connection with Peggy's Cove and for his love of the sea.

*H*e was born Birger Degerstedt on April 14, 1907. The city where he was born, Kaskö, is located on a remote island off the west coast of Finland about 400 miles from Helsinki. This rugged country is highlighted by an excellent harbour which rings the city on three sides. Shipping has always been important; as a result Kaskö has an international flavour. At the turn of the century, Finns worked side by side with Swedes in the forestry and fishing trades. A lumber mill dominated the town and the controlling company built long rows of identical houses which they rented out to workers.

Into this frontier community, the Swedish-speaking Degerstedts settled. The family home was a large eight or nine-room structure. Characterized by long, horizontal bands of wood, three dormer windows and a sharply slanting roof, the house resembled an elaborate and huge log cabin. It was here

The family home, Kaskö, Finland, 1926.

15

Edward Degerstedt, principal of the Swedish-speaking elementary school, pictured below. The building has since been made into a town hall.

Photos courtesy of Tom Degerstedt and the town of Kaskö.

the family of five brothers grew up. William was third oldest. His middle name was Edward after his father.

The father, with his pince-nez, mustache and starched, white collar, was a formidable figure and a strict parent, yet he had his artistic leanings. As a young man he had studied art in St. Petersburg, the old capital of Russia. He was active as an amateur and painted stage scenery and backdrops for theatres. But he couldn't make a living at it so he went north to study teaching. He settled in Kaskö, eventually becoming principal of the elementary school.

A story is told of Edward Degerstedt's student days that takes as its setting the school gymnasium on the occasion of the Tsar's birthday. These were the days when the Tsar of Russia was still monarch of Finland and a Pan-Slavic movement in Russia was intent on Russianizing bordering states. The Finnish students, having been assembled to take part in the official ceremony, were greeted by an unexpected and embarrassing delay. The all-important portrait of the Tsar, comparable to the icon of a deity, was missing. A frantic search was made of the school premises. There were smirks, giggles and all-round amazement as the painting was at last discovered in a toilet in the students' lavatory. Candles affixed to the painting had been lit, adding to the mockery. Rumour laid the blame on Edward Degerstedt, but nothing was ever proven. However the scandal was such that the headmaster resigned.

Now the prankish youth was himself principal. He had travelled full circle, and with a respectable and dignified middle age before him, became active in public politics. He held a seat for several years on an elected jury. But though the position was full of honour, the salary was limited.

Visitors were frequent at the house. Classical music and lively conversation greeted politicians, fellow teachers and the occasional artist. Underneath this social veneer lay an essentially robust and male-dominated environment. There

was a keen sense of competition among the boys. One phrase that was especially common to them was: *He thinks he is the boy,* meaning he thinks he's special. The Degerstedt children would jibe each other with this taunt, at the same time wanting to fulfill the prophecy of the words.

This verbal playfulness extended to physical activities as well and the outdoors played an important role in the games of the five brothers. Swimming and boating were favourite sports. The family owned a cottage on a nearby island and here hunting and fishing were pursued avidly.

Always an early riser, William would be out of bed before any of his elders, off on sketching forays or exploring his environs. He noted the change of the seasons with the delight of any child. During winter, he and his brothers raced each other on skis. They travelled everywhere by this means, making trips of 30 miles or more. One can imagine the boy's first glimpse of the unusual northern lights: canopies of red and green flashing across the sky and reflecting strangely on the snow. At Christmas, William rushed to see the fir trees erected inside the church; night services were conducted underneath candle-lit chandeliers. Nearby a special building reserved solely for the dead was skirted with wonder and foreboding. Each day William passed and noted the harbour full of ships, the iron-cast lighthouse and the windmill on the hill. He visited the lumber yards and marvelled at the purring of the saws.

But an island can be as much a prison as a paradise. The boy, bursting with energy and chafing inwardly at a strict home life, turned to the sailors and fishermen in the harbour as the most adventurous of a small and all too familiar population. These men told him their stories and fired his active mind with a thirst for adventures of his own. The sea was fascinating and it meant escape. He stared at the points of light on the rippling waves and thought of them as stars.

deGarthe has pictured himself in this cartoon as king and judge. The pennant in his hand is labelled "Resa", meaning "Stand up", necessary for those who might happen to grovel on their knees before him.

Fate and history would shatter these idyllic days in the form of the Russian Revolution in 1917. The Finns reacted immediately. A Russian governor was assassinated and Finland declared her sovereignty and independence. It had been a long time coming. Many centuries of foreign rule, first by Sweden, then by Russia, had left their mark on the national character. A Finnish word *sisu*—with no direct equivalent in English—expresses the extraordinary survival instinct of a determined nation. A motto of courage and perseverance, it implies also "a quality of youth, a readiness to face hardship when necessary, and a taste for testing mental and physical stamina against their own invariable elements."[1]

But whatever the feelings of isolation and pride at freeing herself from a Russian master, these were short-lived. Events followed rapidly with direct consequences for the Degerstedt family. One of William's brothers had destroyed a telegraph office and fled to Sweden, chased by Russian police. And when the Civil War broke out between nationalist "Whites" and pro-Russian "Reds", the two oldest brothers saw action. The conflict devastated the country, food was scarce everywhere.

A child of ten, without much understanding of these momentous events, deGarthe years later recalled the Russian cavalry thundering through the streets of the city and brashly performing tricks—slipping under the bellies of their horses and coming up on the other side—the noise, the aplomb, the uniforms, shouts and energy left an indelible image in his mind.

This grim, uncertain time was to coincide with William's school years. His highest marks were—it is not surprising—in art and drawing. He had the example of his father before him and his interest was encouraged. Revolutions often stir a fervor for work, discipline and self-sacrifice. These would be the themes drilled into William until they were second nature. A favourite phrase of his father, the principal of his school, was: *"Arbeit mah' das Leben suss!"*—a German expression

meaning: "Hard work makes life sweet." deGarthe would recall this phrase at various times throughout his life.

Kaskö was not a large enough community to support a secondary school so the children were sent to Christinistad about 30 miles away. Though there was no tuition, expenses for board and lodging were high. The oldest of the brothers, Rudolph, had chosen to stay on in the army after the war. He forwarded his pay along to the family and this money was used to keep William in school.

Shortly after graduation William was conscripted and sent to the military academy in Hamina. He was on his own just long enough to take art lessons in Helsinki. These ended or were interrupted by his army notice and he was on the move again.

Though he was away from home for a second time—like his experiences at boarding school—he was still being ordered about. Calisthenics before an open window and cold showers were part of the morning routine. Under the guise of engineering, the young recruits dug ditches and tunnels, using picks and shovels and crude explosives. William sent home outrageous cartoons of himself surrounded by an avalanche of falling rocks and other lampoons of army life. They suggest no one had a clue what he was doing and spoof the adage: "many hands make light work." In the army many hands make chaos.

Despite useful studies in map-making, deGarthe approached his army training with a feeling of absurdity, of humour mixed with a strong urging to move on. As much as he admired brother Rudolph, generally acknowledged as the genius of the family and a career soldier, the young man dreamed of other things. His imagination was like a feather-light bird, taking flight on the slightest of breezes. In one of his sketches he depicts himself as a king on a throne . A beautiful "queen" sits on his lap, while he calmly supervises the execution of his superior officers. (deGarthe's widow Agnes,

deGarthe's commanding officers await an unpleasant fate. Above and left are details from the same "daydream" cartoon.

19

The passport photograph of deGarthe in 1926, with a page from the same book.

was genuinely surprised at my question: Was her husband upset about his stint in the army? "Why no!" she said. "He was doing his duty and serving his country!")

Serve it he did, but at the age of nineteen, just nine years after the independence of Finland, he applied for a passport to travel abroad. The family was breaking up rapidly. Rudolph and Gustaf were in the army, and Maurice had dropped out of school to join the merchant marine. William was quite impressed when this younger brother (he would call him "the pirate" and "the most travelled man in the family") shipped off in one of the square-rigged vessels he had so long admired. Walking along the harbour front, William must have felt his own destiny pressing close. He would write later: "It looks like we all should be spread out over the entire world, one here, one there, all fighting for the same goal, all with the same expectations."

On the west coast of Finland, immigration was seen as a viable alternative to a war-shattered economy. However, economics were not uppermost in deGarthe's restless mind. He had written on his passport under the heading of occupation: "artist". He may have known what he wanted but not how to get it. That he didn't know how to get it, didn't matter. He was to say later it was the voyage and adventure that appealed to him. Perhaps he would return to Finland and write a book about it all. As so often in his life, he didn't bother about the details, they would sort themselves out at the appropriate time. The main thing was starting, leaving. He wouldn't be back for 30 years.

2 Making a living

*H*e stopped briefly in Stockholm and Halifax, before moving on to his immediate destination — the Canadian backwoods one hundred miles north of Toronto. He moved rapidly, crossing the interior by train. In all probability he was joining a friend. Word had spread there were jobs for immigrants and Scandinavians were prominent among them. deGarthe had no time to look around. As soon as he arrived, he signed on as bushman and was taken by motorboat from Latchford to McLellan. It was here on October 9, 1926, that he began his apprenticeship in the forestry trade.

The work was unimaginably hard, felling trees with "Swedish fiddles " — crosscut saws — and bucking logs to length. A contemporary described this often dangerous occupation as a "locus of crazy, wild, industrial activity, carried on by shouting young men with nails in their boot soles, who travel like smoke among crashing trees." Teams of horses would carry the logs out of the woods on sleighs over iced roads or they would be rolled down a skidway to a lake and piled there until the spring thaw.

The physical nature of the work was new to deGarthe, but he tried to keep up with the older men. After two months in the woods, the tall, brash young man began to get impatient. He had his eye on a larger center where there were more jobs, better money and social activity. There was another man in camp who shared his feelings and together, pooling their resources, they made their way to Montreal.

In the early decades of this century, Montreal was a mecca for immigrants. It was cosmopolitan, a cultural centre and the largest city in Canada. The province of Quebec had rejected prohibition as early as 1919, earning itself the epithet "the sinkhole of North America", but attracting many tourists and other thirsty visitors. Montreal was especially attractive to Americans and the city developed a Yankee flavour. One heard imported jazz drifting through the doors of smoky clubs, as trolleycars rattled along the cobblestone streets. Men wore fedoras and camel-hair coats, while low-waisted, uncorsetted dresses could be seen on the newly emancipated women. To drive the point home, they wore their hair bobbed and short for greater freedom. Rooming houses and cheap restaurants were common. The Montreal Forum had just been built and *les Canadiens* were beginning a hockey dynasty under the leadership of Howie Morenz, while at McGill, under the shadow of the mountain, an economics professor named Stephen Leacock was distinguishing himself as the premier wit of the country.

deGarthe immersed himself in this new environment, drifting curiously through the strange, rainy city; in his own words, "riding the horses of the Apostles", a Swedish expression for walking. He would drop into shops for coffee and tobacco and to try out his halting English. He delighted in the street slang and the colorful atmosphere of the busy city, which he described in a letter home:

> I am in a strange world, lonesome at times, although it is as if I have been wandering about here one thousand

years. Here they are using all kinds of languages: French, English, Polish, German, Italian, Greek and even Swedish, and then Indian and Eskimo—it is really something to listen to. I sometimes think how different it is here and how it would be back in Kaskö, where you see the same people day in and day out.

A stranger recently arrived in Montreal, marching up one street and down the other, never having been in a large city, would marvel at the huge stone colossus, watching the restless, shouting, pushing people tearing up and down, and hearing the ear-splitting noise of the cars honking and the hooves of the horses hitting the cobbled boulevards. The first time I went for a trip out on the streets this was something entirely new for me and I thought if mama came here she would have fainted. I think that father would have been speechless and Lasseman[his younger brother, still a child] would say that this was the upside down world.[1]

His culture shock was considerable, but his most overwhelming response was one of new-found freedom and unlimited possibilities. It would not be easy though. About this time, he wrote: "I worry that sometimes I should feel the pain of hunger and not be thinking about women." He had felt that "pain of hunger" already in Montreal. Living expenses were high and he could find no work. On the verge of catastrophe he found a dime, which he took to a mission. They fed him and his spirits revived. He started to talk to the superintendent. He joked with him and made him laugh. Then in the course of their conversation deGarthe decided to show him something — a cartoon. The man was impressed. deGarthe told him someday he would be an artist. The man had heard many stories from down-and-outers, but for some

"When I'm sailing down Notre Dame Street."

23

"General Zulu dancing during dressing."

reason this one he believed. He arranged for deGarthe to see a printer. The printer liked the work and offered him a job as illustrator with the Dodd Simpson Press. It was January 24, 1927.

The future artist—and millionaire—started at seven dollars a week, but was soon making $20. He bought himself a ukelele and a pair of shoes. He wrote that: "I am beginning to like Canada and feel pretty good . . . I enjoy the music here and there is a lot of that. I am going around singing and dreaming in my own little world." He was secure enough to send home news of his daily activities and of the people he was meeting. In one elaborately illustrated letter he gives an account of a typical day, lampooning his efforts to look the part of a dapper and debonair young man. Getting dressed in the morning he compares to the dance of a Zulu chieftain. Rushing to work in suit and tie through city traffic, he uses terms like "sailing down Notre Dame Street" and "turning a corner like a frigate around Cape Horn." Even in the heart of Montreal, the sea was on his mind.

Like many immigrants at this time, he decided to change his name. Henceforth, Birger Degerstedt would be known as William deGarthe. The ostensible reason was to make it easier for people to pronounce his name, but the change must also have appealed to deGarthe's sense of the dramatic. He was preparing for himself the interesting new role of future citizen and artist. Colleagues at work had encouraged him to enroll in evening drawing classes at the Museum of Fine Arts. With this introduction, new doors opened up for the ambitious young man.

*B*ut just as he was beginning to find a routine for himself, a major disruption occurred. The "pirate" and "bad luck bird" Max had arrived for a visit of indeterminate length. deGarthe was astonished. "It was more than surprising," he wrote. "He

came unexpected and caused a revolution in my sedate life. In addition I had to look pleased and happy, which took some effort." This is deGarthe's humour. Of course, he was delighted to see his brother, despite certain financial difficulties. He describes these: "As luck had it, the fellow had some cash with him when he arrived and that was good because I was broke. The first question I asked him was: 'Can you manage a five?'

"The answer came in broken Spanish [Max had sailed on a Spanish ship and was showing off]: 'Oh yes, hombre, are you broke?'

"'Yes, sir, broke as a church mouse—and three days before payday.'"

This five-note and many more were promptly disposed of as the two brothers unleashed themselves on the metropolis. Along the way, Max related stories from home, doing impressions of their little, cocksure brother, Lasseman, "the family's great hope," going on with his "ideas" about how "he believes that he is somebody or he believes that he is the boy," and how mama would answer that what he really needs is a good "knockout."

These bits of news were interspersed with Spanish phrases and the jargon of sailors. The brothers felt close and were happy at the chance to talk. It was as if they were sharing a bottle of wine and each would take turns drinking longer than the last.

Inevitably, deGarthe made Max the butt of a few humorous observations. His brother, he wrote, "seemed to be terribly fond of dancing and I was almost scared that the floor in my room would collapse on account of his shoes hitting the floor boards. I was also concerned with what the landlord would think, but then I decided it isn't really my business. Instead I tried to dream that I was at the ballet or something because he was twisting and turning his body and his legs looked like corkscrews." On a practical level deGarthe added:

"And then you turn the corner like a frigate around Cape Horn."

"Max is not really a fool, he is clever and has travelled a lot so I believe he will be OK."

They may have been strangers in a foreign country, they may even have been a little awed at the scale and pace of city life, but they knew how to enjoy themselves. Furthermore they were full of confidence and were determined to be themselves no matter what. They welcomed a variety of experiences and

"The five brothers, from left to right: Rudolph, the universal genius; William, artist, pianist and ropetwirler; Lasseman, he with the quick wit and dry jokes; Mauritz, the sea pirate; and Gösta, Napoleon the ?? with his bombastic looks and his thunderous voice." The balloon speeches are in Swedish.

saw it as a kind of test how easily they could handle themselves in different and unknown situations. After disclosing that "I treated him very well and gave him a thorough orientation, taking him to all the city's restaurants, including the Chinaman *Charles* and all the beer pubs," deGarthe explains: "I wanted to find out what kind of a fellow the boy was and observed all his moves and sayings. From all the impressions I got about my dear brother, I came to the conclusion that he quickly became familiar with all he was doing and he was soon at home in any of his surroundings." The description might apply to either man. It seems they both possessed resourceful personalities and had boundless energy. All that was lacking was a job for Max.

deGarthe made inquiries. He consulted his old friend at the mission and they discussed a variety of possible jobs for the ex-sailor. But it was Max himself who came up with the most practical solution. He would become a farmer. "I was dumbfounded," said deGarthe. "I almost fell through the earth. All my proud ideas, all my plans about giving him a good training to be captain of my pleasure yacht collapsed. I recovered — *Well, that's all right.*"

deGarthe would make a joke of Max's decision to abandon a sailing career. His real feelings were more ambivalent. Through Max he had felt a connection to the sea and the ships of his childhood memories. Now that was gone, the link was broken.

Late in his life deGarthe would paint a canvas of a wooden ship leaving Kaskö harbour. It was the boat on which Max first sailed; according to the painter he can be seen in the rigging along with the other hands. deGarthe donated this painting to his hometown and travelled to Finland to take part in a special ceremony. It was his way of saying he remembered and it was important to him.

In Montreal, with the parting of the brothers, deGarthe lost his co-adventurer. He wrote of their last night together:

"Max works as a gentleman farmer."

BROBERLIG SÖMN.

*"Brotherly sleep", with a dream
woman on the easel and a chamber
pot beneath their feet.*

"On Monday the 13th would all of this end and during the night Max dragged large timber logs [he snored]. He knew that this was the last night he could sleep the lazyman's sleep. He relaxed and with his usual patience he slumbered into Morpheus' outstretched arms."

Once deGarthe had seen his brother off on a train headed for the prairies, he threw himself into his work. His employers liked him and he got along well with his fellow employees. But he was restless. At the back of his mind was the open invitation of an aunt to come visit her in Brazil. Since leaving Finland, the idea of this visit had never left deGarthe. With what savings he had, he decided to take his chance and gave notice. He wasn't taking a vacation, he was leaving for good.

deGarthe was impulsive and he followed his instincts. As soon as he landed in Halifax on the Atlantic coast, he headed for the little beach at Point Pleasant Park. He gazed at the water fondly, got down on his knees on the rocks and put his hands in the water. In a minute the water was running over his face. The Kaskö native, island born, had returned to the sea.

Before he left Finland his goal had been "to seek the most beautiful spot on earth." He once told my father: "When I reached Nova Scotia, I didn't have to travel any further."

During his stopover in Halifax, waiting for his boat to South America and with time to kill, he met a man who suggested he introduce himself to Mr. Wallace, an advertising man. deGarthe did so and right away was offered a job. In taking it, he had to say good-bye to Brazil. He didn't intend to stay long, he just wanted to earn a little money and be on his way. But things did not work out quite as he had planned.

*T*he Wallaces were then and continue to be—Ron Wallace is the current mayor—a prominent Halifax family. They owned an agency which was operated by three brothers: Frank, Joe and Howard. The senior partner, Frank, was an

extremely handsome man who thrived on the company of others, yet he was in no way a showy or demonstrative person. His younger brother, Joe, on the other hand, was full of fire. A peerless debater, he carried strong convictions in politics and religion. He was both a Catholic and a Communist. One can imagine the incongruity of a Communist working in the advertising field, promoting the interests of big business. In fact his point of view became so objectionable to clients that he was asked to leave the company. He ended up in Toronto where he was interred in a Canadian concentration camp during the Second World War. He took up poetry in prison, some of which is still reprinted in anthologies.

The third brother, Howard, took care of the Saint John branch of the firm. The company was not large and deGarthe quickly felt at home. He must have looked on with a sense of irony and amusement, even admiration, justaposed between the professionalism of the gentlemanly senior partner and the fire and brimstone of the impassioned and poetic junior partner. Between meetings with high-powered executives—a credo of the advertising business is coolness under fire and the ability to combine creativity with an aggressive business acumen—and a lot of smoking and drinking—there would be talk of Russia, art, people, politics— and a topic of increasing new importance—women.

A friend from that time remembers a whimsical, happy-go-lucky man who mixed easily with people. He rented a room in a family home and became friends with his landlady and her son. This son introduced him to a group of young people who went in for parties and frequent outings to restaurants. They met at Lohnes's on Blowers, but preferred a place on Hollis Street because it was open all night.

In those days no one ever called him Bill or deGarthe. Because of the way he handled himself he became "the Count"—also he was Swedish and they have so many Counts in Sweden. He didn't mind, he was having too much fun,

banging away on a guitar and singing lilting songs with a distinctly military flavour.

Between songs and coffees deGarthe would demonstrate how he made a commercial illustration. He would draw a series of swerving ovals and turn them into images of people. He had great facility and delighted his audiences with the speed and accuracy of his drawings. He did cartoons too. With his landlady he collaborated on a children's book about a queen of hearts who ate too many tarts. The drawings for it were all based on playing cards. They sent a copy off to publishers in the States who were quite impressed but thought the subject was too old fashioned.

deGarthe was an avid sports-fisherman and spent a lot of time with Charles Longley and his brother on Sawler's Lake in Hubbards. It wasn't long before the future artist bought some land for himself in this same resort community and built a log cabin. The acquisition of this land was a significant step for the footloose artist. It is perhaps not a coincidence that he had just become a Canadian citizen, an event marked by a starry celebration on Sawler's Lake.

The poor visibility of the evening added to the fun as a dozen small boats, tied end to end in a long, floating flotilla, crossed the still waters. There was singing and cheering. Laughter seemed to ripple forth from the surface of the lake as three cheers went up in the near darkness: "Hip hip hooray. Hip hip hooray. Hip hip hooray," swelling through the boats like a series of dancing waves. Stars glistened above them; it was one of those perfect, almost magical summer nights.

As the boats bumped the wooden pier on the other side, the revellers stepped nimbly from craft to craft till they reached the hands of those waiting on the shore. And then, as seemed quite natural, the hands remained together and now a human chain, in imitation of the naval chain, made its way up the sloping, sandy path. A large lighted building awaited them. Inside the toasts began in earnest: "To our fellow Canadian, William deGarthe."

It was a wild celebration that went on through the remainder of the night, the guests finally stretching out and sleeping on the floor. deGarthe resisted sleep as long as possible. He was savouring the recognition from so many friends and well-wishers that he belonged and was one of them. All at once the pieces seemed to be falling together. He was a landowner and a citizen, surrounded by friends. He had a good job in the city, yet could enjoy free moments in the country. By most standards of success he had arrived and could be proud of his position. He looked out the window on the lake, lulled by the sweet rippling sound of gently lapping water and the fresh feel of approaching day. He wanted to stay up till it was fully light, he wanted the feeling to last, the feeling of possessing the future, that everything is right. He just wanted to keep his eyes open for the sheer pleasure of seeing.

From his first days in Canada, deGarthe confessed: "I am thinking of getting married." This daydream would have to wait its realization, though girls were frequently on the young man's mind. A line written in Montreal, full of wit and wistful longing, expressed the fear "that sometimes I should feel the pain of hunger and not be thinking about women." He even wrote a youthful poem dedicated to:

> mermaids so pretty
> they are bouncing
> and beckoning
> with their sails high up reeved

However—

> The wind is strong
> and along I stagger
> and presently I get a kick.

He probably received quite a few undeserved kicks for all his romantic intentions. All of this would lead to a historic evening in 1935. The scene was a sprawling, wide-open, down

East party. It was in someone's apartment, no one can remember whose. On one side of the room looking especially dapper was William deGarthe, with his trimmed mustache and oiled hair; on the other side was Phoebe Agnes Payne, tall and elegant. As soon as deGarthe saw her, he was smitten. They danced together that evening and soon began dating. They were married in a few months with — on deGarthe's part — uncharacteristically little fanfare.

There are two stories about the courtship that shed light on deGarthe's character. One has him teaching his future wife the art of fencing, a skill he learned in Finland. It is not hard to picture the two long lithe figures lunging sportively at each other with swords. They eventually stopped the practice as they felt it was too dangerous without masks. They kept the swords though and these are still hanging on the wall of Mrs. deGarthe's private gallery. The other story has deGarthe picking up Agnes at the hotel where she worked and at the end of the evening returning her to the same. The only trouble was that the end of the evening, at deGarthe's insistence, used to come at around 10:00 p.m. (deGarthe was staying in Hubbards, another hour's drive for him.) Agnes found these short evenings so annoying and so contrary to other dates she was used to that at one point she considered dropping this sticklishly conscientious man. Of course, she didn't and the newlyweds ended up with an apartment in the city.

These two episodes contrast deGarthe, the romantic, dashing and unconventional, with deGarthe the self-disciplinarian, equally unconventional, but a pragmatist as well. This last quality was credited as often to Agnes as to her husband.

"I was surprised that Bill got married," said Charles Longley, who was best man at the affair. "It may have happened on the spur of the moment, where he called Agnes the night before and said: 'Will you meet me at the church tomorrow?' But you know, I think that [the marriage] really

turned him around. In two years he was like a different person. Agnes was one of the few people I think who could really *see* something in him. *We all liked him,* but she was the one who helped him. I don't think he would ever have become an artist without her."

This high praise for Agnes was voiced by many people. Originally from Newfoundland, Agnes considers Halifax, where she grew up, her home. Skilled in textiles and weaving, she later became an editor and business woman.

A story is related by Chambers of a sketching trip. He and deGarthe had been travelling down through the Annapolis Valley—Blomidon and Hall's Harbour were favourite spots offering magnificent vistas. On their way back to the city, deGarthe suddenly said, "I must get a present for Agnes." Chambers assumed he meant flowers or candy, but he asked anyway what his friend had in mind. deGarthe replied: "A bag of cement." Chambers remembers thinking: *flowers are perishable, candies you eat up, I don't know about a bag of cement.* The couple were building a back porch or step.

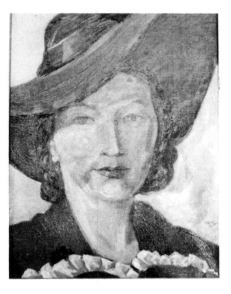

A portrait of Agnes by LeRoy Zwicker, c. 1940.

Agnes did her share of the work, some would say more than her share. She was without question the practical side of the equation of husband and wife and deGarthe benefitted greatly from her business sense and sound good advice. He consulted her frequently and put great weight in whatever she said.

Malcolm Carmichael remembers a visit to Peggy's Cove, where he parked, with Agnes' permission, on a piece of land owned by deGarthe. As he was getting into his car to leave, he noticed deGarthe approaching him. Expecting the artist to make some comment, Malcolm stated that Agnes had told him it was all right to park where he was. deGarthe said: "If Agnes said it's OK, then it's OK with me."

There was a solidarity to the couple in public that impressed many people. When friends came over, they weren't fussy about the usual host and hostess routine. It was informal

33

and relaxed. "If you're hungry there's food in the kitchen. Help yourself," they would say. The style of each suited the other. The deGarthes also shared key interests, such as a love of the outdoors.

During the summer the two moved into deGarthe's cottage on Sawler's Lake. deGarthe commuted each day, taking turns driving with the Longley brothers. Agnes would meet her husband at the end of the day to ferry him across the lake in a motorboat. They took frequent camping trips as well, relying for food on their own resourcefulness as fishermen.

deGarthe, having successfully built one cottage on the lake, now began subdividing his land with the intention of building more cottages. This led to a falling out with the oldest Longley brother, the original owner of the land. He took deGarthe to court—he was himself a lawyer—and won. Because of the bad feeling, deGarthe sold his property. He ended up in Timberlea, where he began again. This time there was no mistake. He intended from the start to build a number of houses and sell them off as they went up.

*O*n a psychological level, deGarthe's many house building projects could be seen as an expression of his own unresolved need for a home. He liked to have a summer place, a cottage or camp, some place he felt he could escape to. A pattern developed where he would invariably give up his main residence, move into the summer "cottage" on a more permanent basis and then start to look for a new second home. For most of his life he simultaneously owned and lived alternately in two homes. This would culminate in his excursions to Florida and the West Indies for the winter seasons and residence in Peggy's Cove in the summer months. Obviously he felt a strong desire for a home, but was incapable of settling down and living in just one place.

The setting in Timberlea was ideal. A small, still largely wooded community on the outskirts of Halifax, it

accommodated a lumber mill on a series of interconnected lakes. From this mill the deGarthes got their wood to build first a two-room cottage and later a four-bedroom two-storey house. The carpenters, who came from Hubbards, stayed in the half-finished house during the week as they worked. deGarthe oversaw their plans and brought friends out from Halifax to help with the construction.

After the second house went up, a mason was hired to install a fireplace. The job wasn't proceeding very satisfactorily, however, so deGarthe dismissed the man and tore the thing apart. "He hadn't a clue how to build a fireplace," Agnes told me. "But he went to the library, got out a few books, and well, he just built it himself." Did it work? "Oh, yes—marvellous!"

Initially the house was used on weekends as a retreat outside the city. But neighbours soon convinced them of the advantages of living there year round.

deGarthe was quick to make new friends. He called out to a neighbour rowing on the lake: "I've been wanting to meet you. Drop by on your way back and we'll have a talk." The man did so and they became such friends that he moved in for a time with the artist and his wife. Every New Year's Eve, the deGarthes would host a party. At 12:00 sharp, one of the guests would proceed onto the veranda with a shotgun and fire a round into the night sky.

deGarthe took an active part in the life of the community. He taught the two daughters of one neighbour to play the piano and was a moving force behind the formation of a benevolent society that assisted in local charities.

It was a laid back and pleasant existence. One day a neighbour was trying out a punt on Fraser's Lake. deGarthe maneuvered a rowboat alongside him and suggested they race to an island at the mouth of the system. The artist gave his friend a ten foot head start, then shot past the ineffectual punt with effortless turns of his oars. He glanced over at his

35

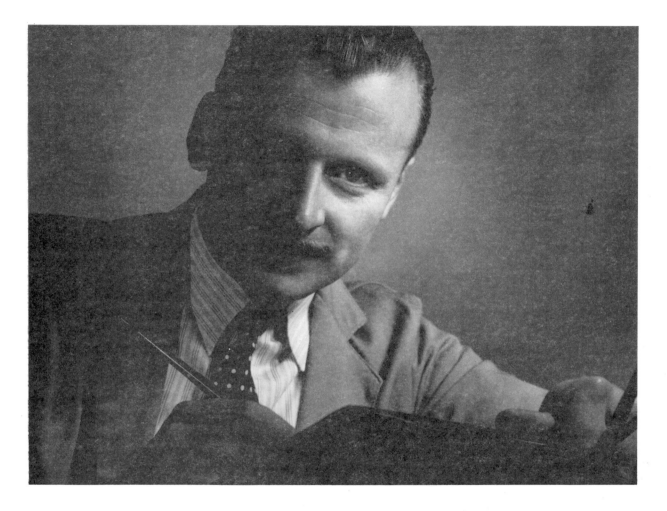

Advertising man, 1948.
Photo by Edward A. Bollinger.

struggling friend and without breaking into the slightest bit of a grin—deadpan—said: "Come on, Mac, you can do better than that." He then pulled away with the same methodical strokes.

deGarthe thrived in this environment. In winter he constructed a sail out of canvas and dragged it down to the frozen lake. Here he donned skates and demonstrated a sport he had learned as a child in Finland: wind-skating. With the sail raised high behind him, he would skim over the clear black surface of smooth ice while Agnes on skates and the family dog romped behind. deGarthe, racing miles ahead, oblivious of ordinary limitations, resembled a Greek hybrid of half-man and half-bird. Neighbors had never met anyone like him — in a tiny universe, he was a sensation.

There were times when the artist preferred to be alone. Wading across a shallow section of the lake, he would make his way into a bluff of pines. A path led to a clearing, where a circle of huge stones had been placed. This became deGarthe's private Stonehenge in the woods and it was here he claimed he got his best ideas.

He continued to work in the city, keeping up his many associations. Among his city friends were members of the newly formed Armdale Yacht Club. deGarthe had lived briefly on Halifax's Northwest Arm near the club's site on Melville Island. He and Ron Wallace would later collaborate on a bulletin for the club, Wallace doing the writing and deGarthe the illustrations—of ships, the sea and caricatures of yacht owners and members.

deGarthe joined eight or ten of these sailing enthusiasts each day for lunch at Lohnes's restaurant. This group, composed of business leaders and keen sportsmen, were especially intrigued by the international schooner races, which began in 1920 as a challenge between Canada and the United

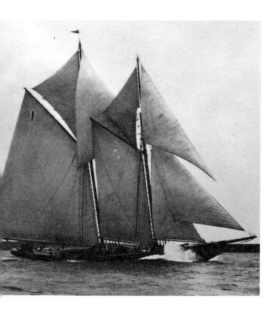

The Bluenose.
Photo courtesy of the Public Archives of Nova Scotia.

States. Only schooners that had actually spent a season on the Grand Banks qualified. The *Bluenose,* designed by W. J. Roue and built in 1921, began to dominate these events, eventually winning six races.

However there had not been a race since 1931. Wind-powered ships had long been superseded by their modern counterparts, the so-called "iron kettle pots" or "stink pots". It was as an antiquity that the *Bluenose* had been exhibited in the World's Fair in Chicago, and on a similar standing she had taken part in friendly regattas in Great Britain. Recognizing that soon there would never be another opportunity for a match-up of schooner against schooner as in the days of old, there began to be a great demand for a revival of the International Fisherman's Trophy. In 1938 they reached an agreement. For one final race the *Bluenose* would take on the most qualified American challenger, the *Thebaud.* As all Canadians know, the thrilling race took place off Gloucester and Boston and the *Bluenose* emerged triumphant in what many consider the closing of an era.

Throughout the race, the mood in the city of Halifax was one of tense expectancy. The *Halifax Herald,* which sponsored the event, broadcast progress of the race from loudspeakers and had replicas of the ships built and displayed in office windows.

The finish—the *Bluenose* won a fifth race to break a tie of two victories each—was described as being "as dramatic as any in which the rugged old champion ever won fame." Headlines reading: "Bluenose Still Atlantic Queen" and "Bluenose Victory Her Greatest" bumped stories of the escalating war in Europe to minor captions. Yet the sense of finality, of encroaching obsolescence and of a victory containing as much sadness as joy is apparent in lines like these: "Heavily handicapped by years, woefully out of condition, in no shape to do what she used to do, yet champion comes through." An editorial under the heading "Valhalla or Oblivion?" noted the

strong feeling of identity of residents for their most famous native vessel: "For this grand old champion the Nova Scotia people have a deep and abiding affection. To all of us she is not just a mass of inanimate wood and cordage and canvas—she is a living thing with personality; honest, faithful and true."

Feelings ran high, but not high enough to save the actual ship. The *Bluenose* was sold to the West Indies Trading Company and eventually it sank off the coast of Haiti in 1946. One of the few regrets of his life, deGarthe would say later, was the failure of the government and Nova Scotians to save the *Bluenose* and to make a national treasure of it.

Back in 1938, it was the biggest sports story of its day. Interest was so high in Boston that the race was given preference in news space over the World Series. Among deGarthe's circle, it fired their interest in the schooner as a unique and remarkable vessel. So much so that they made contact with the same Roue who designed the *Bluenose* and from him commissioned vessels of their own. They organized local races in an effort to keep the spirit alive. deGarthe had a keen interest in these developments, though he owned or commissioned none of these boats. He would promote the schooner's memory in his own fashion — in oil paint — and perhaps more successfully than any of his yachtsmen friends.

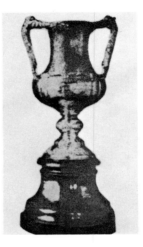

The Fishermen's Trophy, donated by the Halifax Herald.

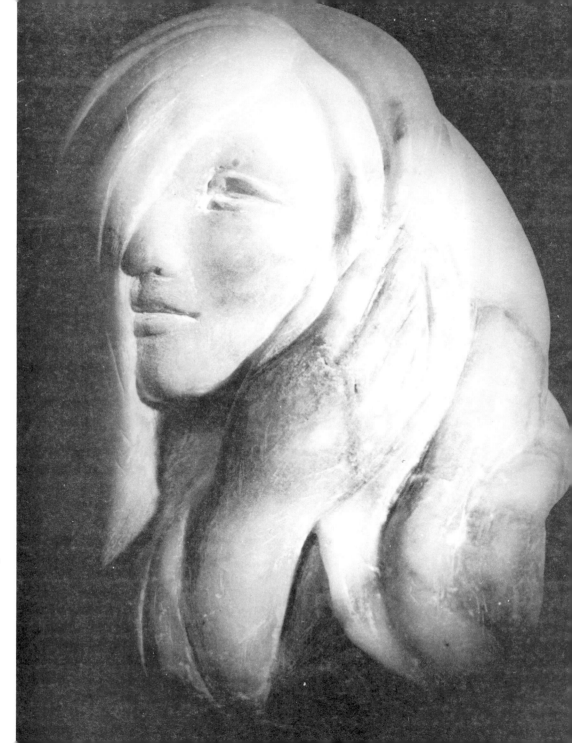

*Marble head of a
woman touching her
hair. The effect of the
figure emerging out of
the rock before our
eyes suggests an
awakening conscious-
ness. The face
resembles Agnes but is
very stylized.*

3 Emergence of an artist

*A*s noted by more than one observer, Halifax is a city that waits for war. With its immense ice free harbour and strategic location, its destiny seems inevitably to play host to sailors. My mother had just started university when the war broke in Europe. She tells me it was very difficult to find accommodations in the busy capital. She eventually found a room in a house owned by an army chaplain, a forthright man from Newfoundland who greeted visitors to the manse with this injunction: "Step aboard, and welcome, bye!" It was a hectic and exciting time.

Mrs. Marguerite Zwicker, a former gallery owner and noted Nova Scotian artist, remembers those years with mixed enthusiasm. "You can't imagine what it was like, Bedford Basin would be full of ships, the streets would be crowded with soldiers and of course some of them would be artists or interested in art. We made friends with a lot of these young men. You'd ask if they were busy Friday night. They'd say no, so you'd invite them for dinner. Then we'd have to scramble to get enough stamps to buy a large chicken—we ate chicken because it was cheap. You see, none of us had any money in those days."

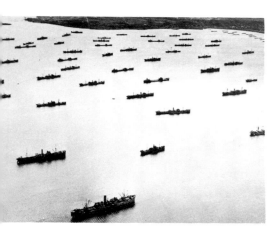

War ships in Bedford Basin.
Photo courtesy of the Public Archives of Nova Scotia.

The atmosphere was a curious blend of camaraderie, fellow feeling and a willingness to share, mixed with an unnatural prudence, enforced suspiciousness and a tight rationing of daily necessities. Though the city appeared to be open and bustling, it could not ignore the lengthening shadow of a bombarded city like London at the front of the storm.

deGarthe was keenly aware of what was happening overseas. When Russia invaded Finland in 1939, he was all set to join the Finnish defenders at the Mannerheim Line. With soldiers fighting on skis and snowshoes, the conflict would be known to history as the "Winter War." He had been in touch with his father. The stern headmaster told him that he had four sons at the front already. He dreaded the possibility of losing the entire family and begged William to stay where he was. His son relented and remained in Canada.

This one exchange must have registered as much as any other single incident the fact that he had cut his ties with his native land. He was no longer Finnish, but Canadian with new loyalties in North America.[1]

Because of the war, there was felt a need that it be documented in a meaningful way. The government turned to its artists, who readily consented. They were sent overseas to make sketches of all facets of army life. Many of Canada's war artists—most significantly Alex Colville—went on to become major figures.

deGarthe was not a war artist, yet ironically it was during the war that he became an artist. The profession had always intrigued him. His early writings from Montreal refer to the power of the word "artist," and how it brands one apart from society. At 20-years-old, deGarthe was still self-conscious and youthfully defensive: "I am proud to be an artist. I am not a pseudo-artist, despite what people say." How different would be the tone of his later writing, as in this letter to his wife: "You know me, I do anything, not thinking of the work or the difficulties involved, and I sure started something this time!"[2]

With the war everything changed. The war brought people together, it heightened sensibilities and created a feeling of urgency in just about everyone. There was a buzz in the air; people wanted to do something to contribute and to be a part of the national effort. But what could deGarthe do? He felt cut off from his family and past. A spiritual void opened up that he needed to fill and his urge to paint took as its source a deeper stimulus, a need to define himself and to communicate with others.

*E*merging at this time was a coterie of artists, Halifax's own round table of ready wits. Among these were Marguerite and LeRoy Zwicker, artists and gallery owners (theirs was the first commercial art gallery in Halifax); Robert Chambers, who was soon to become a household name through his daily cartoons in the *Halifax Herald*—"He is a Leacock, a Thurber, almost always gentle, rarely bitter, leaving no scars on his victims," wrote a contemporary; Robert Norwood, a talented professional photographer who had studied under Edward Steichen in New York; and William deGarthe, illustrator, ad man and artist. They were joined by naval war artist Leonard Brooks, a burly, brusque and energetic man who set up impromptu studios in the livingrooms of friends, then ruled them like tempests. "He would stride imperiously about the room, paint over everything, brush in hand, undefeatable," was Marguerite Zwicker's memory of him. Norwood, she said, was "crazy, absolutely crazy. We all were. You know artists nowadays, that's how we were. We had a lot of fun."

If Norwood was ready to mock anything, with a wit that was sharp and unusual, Chambers' was a gentler humour. At that time, he was a journalist as well as a cartoonist and like many journalists of his day he covered the Moose River Mine disaster in 1936. He'd gotten his call—an emergency, rush, big

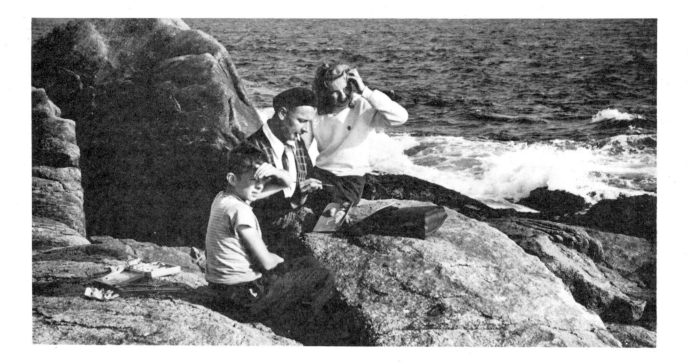

deGarthe with model Gloria MacLean and young friend in Peggy's Cove.
Photo by Robert Norwood.

story—in the midst of a black tie party. He threw up everything and hurried to the mine site, still in his tuxedo. A Montreal newsreel cameraman asked him about his dress and was asked in turn: "Didn't you get your invitation?" Another story is told of visiting Chambers at the *Herald*. He worked in the basement, tucked away in his own little niche. There was a man conducting a tour of the building. It was his first week of work at the paper. He knew of Chambers' corner but had never been dcwn to visit; somehow he had the impression that it was a forbidden sanctuary. Now in he comes with a group of some twenty excitable school children in tow. Chambers looked up and beckoned them in. "No one ever visits me, they've stuck me in this dingy hole!" he said. "Come in!" He

talked to them all, entertained them as he worked. A daily cartoon is a tough deadline to meet. Were they disturbing him? Hell, no! They relaxed him and he told them he did his best work when relaxed.

The same might truly be said of any in that group. They were convivial; their high spiritedness ran close to the source of their inspiration.

*T*his was the crowd that met each day for lunch in the empty room on the floor above the Zwicker's Gallery. Brooks took it upon himself to paint a mural on the wall above the fireplace, an ambitious effort depicting elephants and various mythological figures, mostly nude. (Mrs. Zwicker told me she often wondered what became of this after they sold the gallery. A Leonard Brooks watercolour nowadays would easily command in the thousands of dollars.) The lone worker in the gallery would hear guffaws of unrestrained jocularity drifting down the stairs. The inner circle was lively, easygoing and poor, yet ambitious. But woe to the one who put on airs — often deGarthe — in this company of brilliant jesters.

It was Agnes' birthday and deGarthe and Mrs. Zwicker reached an agreement. She would cook the dinner and serve as hostess for their party if deGarthe would prepare the drinks. In a spirit of liveliness that bordered on devilry, and with a dash of competitive machismo, deGarthe dispatched his mission. The drinks were handed out—cocktails with more ingredients, all intoxicating, than a Swedish smorgasbord. Not that this was the company that would ever betray the fact. Now it happened that deGarthe, finding no challenge as tantalizing as his own, drank several, one after another. To the amazement and bewilderment of the assembled party, he disappeared. It was Chambers, steadfast buddy, who sought him out, found the unconscious form on a couch in the back room, recorded it for posterity and then began himself the difficult task of finding his

Bob Chambers on location, c. 1950.
Photo by Robert Norwood.

way back to dinner. According to one witness, he said: "I saw a dim light at the end of the hall and figured that's what I should head for." Whatever became of his fabled cartoon of that raucous evening, no one knows. He may still have it, but protective of his friend, he denies the fact.

However it was Brooks, sleeping in the living room of the Zwickers' modest apartment and later, with his wife, staying with the deGarthes in Timberlea, who was the most developed of these budding artists. His was an enormous influence on the marine painter, through his example and his encouragement. deGarthe said in a published interview that "my wife gave me my first paints, Leonard Brooks gave me my first advice."

An apocryphal story is told of deGarthe, then a respected commercial illustrator, unwrapping a present to find inside a toy set of children's paints. A jest perhaps — from his wife — but he took it seriously and decided to become a painter. (Was it on his mind, an unspoken desire, so that the present seemed too great a sign, a synchronicity, to be ignored?) The presence of Brooks, a man who took his own art seriously, helped.

Between painting sessions he and Brooks would "jam" together, with Bill on piano and Leonard on violin. A song they played evening after evening was "Hearts and Flowers", a tearful piece—in their hands—they soon mastered and played to the hilt. It became their in-joke, theme song and anthem.

deGarthe continued to further his studies during these years. He took advantage of slow periods in the advertising business to sign up for brief semesters at Mount Allison University in Sackville, New Brunswick. There was also a school at Gloucester, Massachusetts that attracted an international crowd of marine artists. Marguerite Zwicker described it as a kind of resort: "It was more of a social gathering. People came to have a good time. I never felt I learned anything. But Bill, he came back and I really think he absorbed something. It may have been that he was more intent on learning; his work improved a great deal after that."

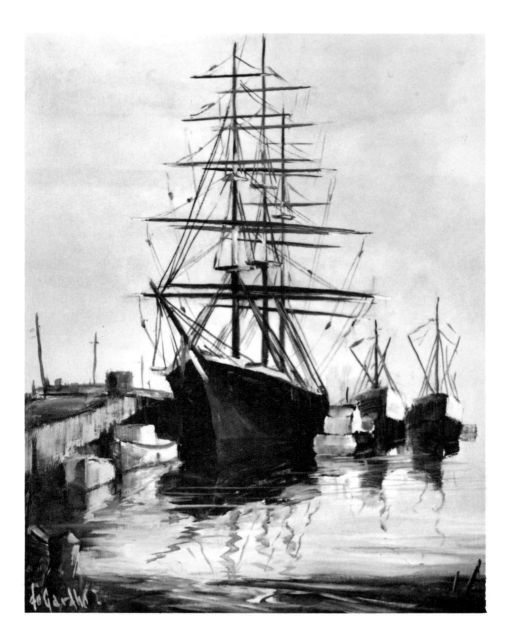

Flying Cloud, *a 3/4*
replica of the original
built at Meteghan,
Nova Scotia in 1966.
This oil sketch was
painted on the spot.
49 X 39 cm, collection
of the Public Archives
of Nova Scotia.
Photo by George
Georgakakos.

This huge canvas, approximately 210 X 136 cm, depicts many recognizable features of Peggy's Cove, though reordered to suit the needs of the composition. The house directly below the church is deGarthe's. Some of the religious symbols in this painting are derived from Free Masonry, a Christian brotherhood deGarthe belonged to for many years.
Collection of Agnes deGarthe

deGarthe himself often talked about New England painters as his mentors in the marine genre.[3]

He studied modern motifs as well, attending the Art Students' League in New York. Here he fell under the tutelage of the famous German satirist, George Grosz. He met other artists during this stay, most notably Salvador Dali, the Spanish surrealist. He would later call Dali his favourite artist—an absurd idea, worthy in its very audacity of either man. Yet the comparison is interesting. They were both showmen and unabashed self-promoters, with a keen interest in a variety of media. Both men found their natural flamboyance led them easily to advertising, a field in which overstatement, the startling idea or gimmick, and the ability to move people in a decisive way in an instant, is paramount. Ultimately, it was Dali's religious pictures that deGarthe admired. He once attempted a rough copy of one, though set in Peggy's Cove, with Christ hovering in the sky above the rustic fishing village. Dali technically was a virtuoso, a superb draughtsman and extraordinary manipulator of space. His famous crucifixes suspended above the earth, look as though they are seen from outer space; the space depicted is absurdly deep, the impression is uncanny and eerie. deGarthe was also interested in capturing a sense of space, especially the deep recesses of foggy coves and open oceans—a girl said of one of his pictures that it gave her goose bumps just to look at it. There is an eerie, supernatural quality also.

After these diverse and expansive studies, it must have been something of a shock to return to Halifax, in those days a city without even a public art gallery. However it wasn't so different in the rest of Canada. The biggest problem seemed to be one of public perception. To buy art is one thing; to buy it from your fellow countrymen is something else. It was the Group of Seven who threw open the doors for Canadian artists. They were the revolutionaries and their gospel text was: Canada by Canadians. No more copying Europeans

starting with what you paint. No pretty gardens, no portraits of aristocrats or drawing room scenes or cafes or that whole scene of decadent urban bohemia that started Picasso and so many others on their young careers. What at that time was so blatantly unique to Canada was the land. Not a cultivated plot or dreamy, tidy, woodsy Arcadia. Land, unsettled and wild. The titles themselves are indicative: "The Jack Pine", "Stormy Sky Over Hudson's Bay", "Night Camp", "The Tangled Garden", "Terre Savage", "The West Wind". They are emotional pictures where the artist identifies deeply with a mood or a condition or a vista of nature and transfers something of himself—his own inner emotional state—onto the scene. Though they are landscapes, they are also "personal" pictures. It is why people looking at the paintings can so easily identify with them.

This detail from the painting reproduced opposite, showing a woman carrying a basket of fish, may be an early prototype for the legendary Peggy of Peggy's Cove, an "earth-mother" figure of whom more will be said later.

Collection of Agnes deGarthe.

*G*roundbreakers in boosting Canadian awareness of themselves, the Group of Seven encouraged other artists to paint out of their own experiences and feelings and they accustomed the Canadian public to looking at and appreciating home grown art. But the money and the aesthetic do not always follow. Widely appreciated now, in the 1920s and 1930s their work was practically unsaleable. Most members were penurious. The painter A. Y. Jackson spoke of never dreaming of getting married, he couldn't even afford the rent on a decent apartment. Varley never made enough money to bother filling out an income tax form until his 70th year.

deGarthe understood the dilemma in these terms: "The struggle is to become known. It is tough. The artist, like the writer, must be sensitive and he must be able to get over the disappointments . . . and then someday you get the break." The man was the heart and soul of optimism. Even some of his closest friends wondered at his talent when he first started. His

compositions were crowded, his colours were dark, but he worked hard and he improved quickly. He was still a commercial artist, but he was painting his own pictures on the side. Other artists were invited to his studio. He was always gregarious and congenial. They would hire a model—often a sailor roaming the streets—and work, sketching side by side.

An association of artists was formed and it became an important step in promoting their work. They put on shows in libraries, shopping malls, and once in the ballroom of a hotel. The important thing was getting their work out to the public, getting comments, raising an awareness of themselves. Of all the artists who took part in these exhibitions, none received more attention that deGarthe. His paintings were phenomenally popular with the general public. This story reprinted from the *Halifax Daily Star*, is one of many examples:

PAINTING STEALS HEART OF BELLHOP
by David MacDonald, Staff reporter

There were 82 paintings mounted on display in the hotel ballroom but the wide-eyed bellhop saw only one. Every chance he could get away from his duties, he would hurry to the exhibit to gaze at a painting of a churning Atlantic surf. "Moonlight over Peggy's," artist William deGarthe called it.

The bellhop, 31-year-old Gordon Stewart, called it the most beautiful thing he had ever seen. It seemed to cast a spell over him. In off hours he would sit for as much as an hour at a time, taking in its beautiful blue tints. Even after the spring exhibit was over and the picture was removed to the artist's studio, Gordon couldn't quite forget the canvas.

So he went to see deGarthe. He told him of his fascination for "Moonlight over Peggy's" and asked if the painting might be for sale.

"I was really moved by his sincerity and love of the picture," deGarthe relates. "I don't know if he knows a thing about drawing or painting, but he has the soul of a real artist and that's what counts."

As a matter of record, the artist lowered the price of the picture greatly and turned down several handsome offers for it in order that the bellhop might have it.

NOT AN ARTIST

"No, I can't paint—not a bit," answers Gordon Stewart. "But the 'Moonlight' . . . it's sort of an inspiration to me, if you see what I mean. There's a tiny lighthouse out over the waves that seems to be a symbol of faith . . . well, mister, what I mean is, that picture has everything I couldn't have otherwise.

"You may buy something because you feel it will make you or somebody else happy. I'm buying Mr. deGarthe's painting because just looking at it does the same for me," he explains.

And he will soon have the canvas. With a reduced price of $75 on the painting, he's paying on the installment plan. Two dollars a week of his tip earnings are put aside so that by next spring "Moonlight Over Peggy's" will be his own.

Buoyed by encounters like these, deGarthe decided to leave the Wallaces and start an ad-art firm of his own. He was well known and respected in the marketplace and his confidence was growing. The business end was looked after efficiently by Agnes, so that deGarthe, setting his own hours, spent a share of each day on his personal work, as well as taking the time to travel and to study.

deGarthe was ready to grow and was looking for an outlet for his boundless energy. There was his art, of course, but he was looking for something more.

Charcoal sketch: "Peggy's Cove,
July 1, 1955 8:15 p.m."
Collection of Agnes deGarthe.

One constant in these transition years was deGarthe's love for Peggy's Cove. Now a popular tourist spot, the cove is located on the south shore of Nova Scotia about 30 miles from Halifax. The setting is unique, with its odd configurations of Ice Age old rocks and boulders strewn like giant Easter Island heads all about the scrubby hills and windswept shore. As one passes through this desolate terrain, conversations stop; a silence, eerie and respectful, overcomes all. The feeling is one of disembarking a time machine and entering the past.

It is another world inside the village: the houses clinging to the sides of rocks, the gauntlet of wharves, the water lapping up to and under many of the sheds and the pervasive smell of sea-salt on a refreshing breeze. There is a deep feeling of security in the cove, but if one cares to go beyond the village and climb among the rocks on the edge of the ocean, breaking waves will rise up before you, crashing like an orchestra of a thousand cymbals. From pinnacle viewing-points, one gets a glimpse of oversweeping power. There is a sign on the lighthouse warning visitors that careless viewers have been rewarded with injury and death. One looks back at the pounding surf with a greater solemnity and a little more respect.

At first, the deGarthes came for weekend visits. They stayed across the street from the site that would be their future home. Agnes remembers being exhausted from the week's work, running the business in Halifax. Her husband would get up before anyone else and disappear without explanations. They all knew where he was; if they went far enough they might even catch a glimpse of him sketching on the rocks. Agnes would pass the day by herself. Often she'd find a rock and lie down and rest. The village was very quiet—no tourists in those days—before long she would fall asleep.

Often they stayed at the Lover's Lane Inn in Indian Harbour. The proprietor was a fisherman. He had built a cabin behind his house and put up a sign. deGarthe made friends with him, asking if he could go out with him on one of the

The gate at the entrance to Peggy's Cove no longer exists. In the background can be seen St. John's Anglican church.

boats. The man had no objection; he often fished with a neighbour's son, Keith. Soon it became a habit. The three of them would set out at dawn and go ten to twenty miles out. When they reached open sea, they would bait and set their lines. Handlining it is called. There were no cranes, no poles; when a fish bit, you pulled him up. To add a little interest to the activity, deGarthe offered a dollar to whoever caught the biggest fish.

> We used to have a great time with him aboard the boat, Keith Cleveland recalled. He'd look at me, 'Well, a dollar for the biggest fish.' One day he had the biggest fish in the boat and it was late in the afternoon. Weather was nice, fine. I lay down kind of on the stern — she was once of those Cape boats — and I had two lines, one over each side. First thing I know, one of the lines caught. I got up and started hauling. Mr. Hubley said to me: 'You got a fish?'
> I said, 'Yeah.'
> Mr. deGarthe said: '*Nooo,* he's just trying to fool us.'
> I played that fish for quite a while but I got him up and into the boat — that fish must have weighed close to 70 pounds, a cod fish. Well Mr. deGarthe stood there and he looked at me. After a while he walked back through the boat. He reached in his pocket and he said, 'Well, I guess you got the dollar.'

This incident is related with such pride and such a wondrous sense of achievement, we again enter the world of childhood and get a picture of how fine and uncomplicated those days must have been.

The artist was relaxed on these outings, at home in a boat and in the presence of his friends. One day they asked him about his accent. He explained that he was Swedish and gave them a sampling of that wonderful language. As he spoke—one can imagine the rugged sunburnt face of Charlie,

the skipper, and the amazed countenance of Keith, the hand, both rapt with attention and admiration—his line suddenly went taut. deGarthe had landed a fish. He developed this into a gag and it earned him the nickname "the Magic Man". For whenever he broke into his native tongue, a fish invariably bit.

deGarthe went out several times on each visit to the inn. Come fall, Keith unwillingly left the men as he had to go to school. Charlie and Bill would proceed alone, swapping stories and sharing jokes. But as Charlie regaled his companion with stories of old times, it must have been clear to them both that the flow of history was against them. The men and ships were changing and who now remembered how it used to be? This question may have lingered with deGarthe back on shore and strenghtened his desire to create a record of the disappearing ways in canvas and paint.

For the immediate future, there would be innumerable sketching trips with Chambers, the Zwickers, Brooks and Norwood. He once dragged along his boss, Mr. Wallace. Later, he would bring out his many classes. Tony Law remembers visiting one weekend. He got up in the morning to pouring rain. So much for the day! he thought. He started to look for deGarthe. He's outside, he's told. Outside? "Yeah, with his class!" And true enough, on one of the wharves there are twenty young Homers and the old master busying about from easel to easel, characteristically gesturing to all, "OK! OK!"

deGarthe talked about this psychologically entrancing aspect of painting:

> You forget everything except what you are trying to do at the moment. Time doesn't mean a thing. You are in Elysium. Even spectators, if they keep quiet, may be unobserved or at least unremarked. They may, of course, be very disconcerting when they suddenly make their presence known. I remember very well an amiable and respectful cow who had been looking over my

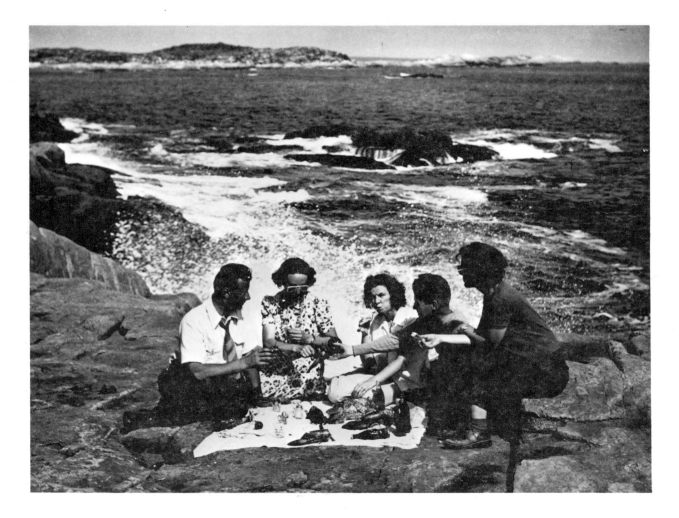

*Lobsters and Coke, c. 1940. From left
to right: Bill, Agnes, an unidentified
couple and Ruth Norwood.*
Photo by Robert Norwood.

shoulder (I suppose) for some time, completely unknown to me. At length, being unable to contain her disapproval any longer, she voiced her opinion of my work in a loud "moo!" practically down the back of my neck—with results you can imagine.

From Marguerite Zwicker I heard a similar story, as I did from David Whitzman. They all visited Peggy's Cove in the early days, before the village had installed electricity. "When it got dark, you went to bed," Whitzman told me, "there was nothing else to do." Those were the days of the famous gate, a hinged wooden gate that swung over the road at the entrance to the village. (Originally designed to keep cows out of the village; to a modern observer it is inconceivable how a cow could survive on the pasturage of a land appropriately called "The Barrens.") Children used to man the gate, charging cars that wanted admittance five cents or ten cents.

Mrs. Zwicker remembered well the weekend visits. A local resident would put them up. They'd scatter, set up their easels, paint on the rocks. When lunch time arrived, their hostess would ring a bell, signalling them to return. Paints, easel and canvas would be dropped, abandoned wherever they chanced to be, to be continued on or rounded up later. They ate with the local fishermen who saw nothing unusual in this company of artists. Sometimes they would picnic on the rocks, picking up a dozen or more lobsters fresh off one of the local boats.

Chambers remembers an occasion when the four men came down alone without their wives. They were just sitting down to supper when deGarthe out of the blue announced he would say the grace. The hostess couldn't say no. None of the other artists had heard him say grace before. In his own flamboyant way, he made up the words and once it was done, it seemed natural.

On another occasion, deGarthe had his friends up well before dawn. They rode out to a uninhabited spot and

proceeded to set up their easels. It was pitch dark and raining, but the men, undaunted by such minor considerations, started to paint. Their wives had more sense and stayed in the car. If deGarthe was able to cajole his friends into such an adventure, it was a favour that was reciprocated. "We did a lot of crazy things," Marguerite told me, "and if someone suggested something, we did it."

There is an extraordinary piece of film footage, dating from the sixties, showing deGarthe's tall, lanky frame before an easel. He is outdoors, working quickly and spontaneously. Before him lie rocks and the ocean, nothing else. It is a desolate, wild spot; he is very much alone and rather incongruous looking with his beret and paints. Waves come rolling in toward him. He jabs at the canvas, applying paint rapidly and deftly, using several brushes. Then a wave crashes on the rocks before him, rising twenty to thirty feet high, for a second it towers above him and looks as if it will surely engulf him. The sound cannot be described. In its suddenness, its explosiveness, it is a sensation that tears through your body— like a scream in a movie theatre—at once frightening and intoxicating. It becomes a sound you want to hear again and again—and of course if you stick around for even a minute you do. The many wave sounds overlap each other, some near, some far; it's no wonder people get bewitched by it. The painter works on rapidly in the dying light, throwing himself into the mood of this wild, chasmic sea.

Ned Norwood told me how they came to shoot this particular bit of film. He had approached deGarthe and discussed what he was looking for. "I said, 'Bill, let's go somewhere where it isn't all built up with tourists, I want a real sea shot, something wild.' That's all I needed to say. He knew just the place. It was getting on in the afternoon and the sun was going down so we had to hurry. Because of that, I'd never be able to find the spot again. It was between Peggy's Cove and West Dover. Bill was a great walker, he was familiar with the

Photo by Robert Norwood.

58

whole area. We had to pass a point, a ledge of rocks surrounded by water. So we stopped and waited for the largest wave, every seventh or twelfth. We'd let the next one go by, then run like hell. Eventually, we came to a breakwall. It was ideal because the waves when they hit, they go straight up, 20, 25, 30 feet, very high. deGarthe had his own expression for it: 'You gotta wait for the ripper.'—that was the big one, the seventh. It's a horrifying sound the first time you hear it.

"Another place we used to go to was on the other side of Peggy's near Indian Harbour. It's called the Whaleback, because of the shape of one of the rocks. There's a good-sized hollow in the rocks there, polished smooth the way the rocks get. It would fill with water; when the tide went out, you'd have a shallow pool. The sun would warm it and make it perfect for swimming. We used to go there a lot, impromptu swimming parties, my father and mother, Bill and Agnes, they would bring others along as well. One thing, he loved what he did. It's a great life—to be able to get up and go to one of these spots whenever you like. When you're an artist, you set your own hours . . ."

These outings are reminiscent of—if less rugged than—the exploits of those other famous outdoorsmen-painters, the Group of Seven, with their frequent trips to Ontario's sprawling lakes. (Members of the Group used to carry heavy rocks along in their backsacks to build up their endurance, and at the end of the trip, they'd climb trees and deposit the rocks in the upper branches.)

David Whitzman—it was practically the theme of his talk with me—lamented the lack of true landscape painting, by which he meant painting done outdoors to nature. Nowadays, it's all done to photographs indoors in full comfort of accompanying CD's and televisions. His other lament for the old days was for the fellow feeling of artists, the camaraderie, the social interaction and generally the awareness of what others were doing.

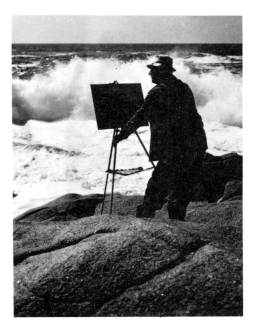

Photo by Robert Norwood.

When I asked a woman who has lived in Peggy's Cove all her life how the villagers regarded these early visitors, she said they were accepted easily. They had a genuine appreciation for the cove and they were dedicated to their work. In those days the artists were the only visitors. Wherever you looked, you'd see one on the rocks. Now she says, though there are thousands of visitors each week, they don't ever see an artist sketching on the rocks.

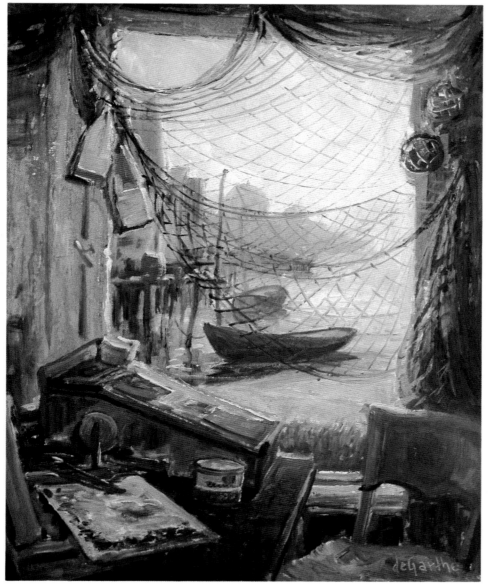

**Through the
Studio Window**
Oil on board, c. 1960
45 x 30 cm. Collection
of Mrs. Agnes deGarthe

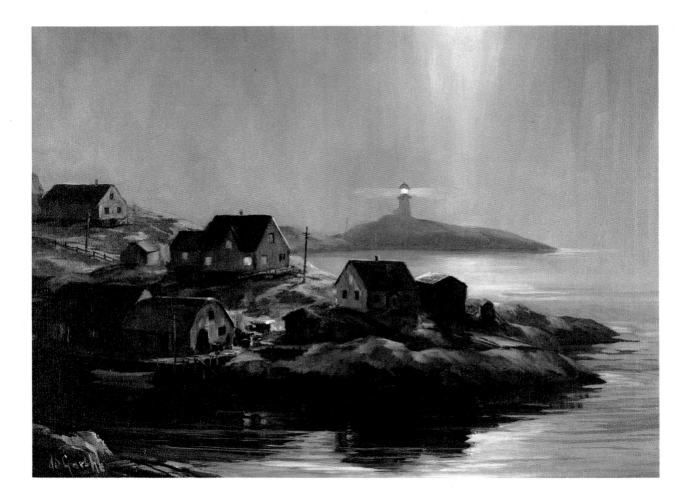

Moonlit Cove
Oil on canvas, 1965. 45 x 60 cm. Collection of the Nova Scotia Power Corporation

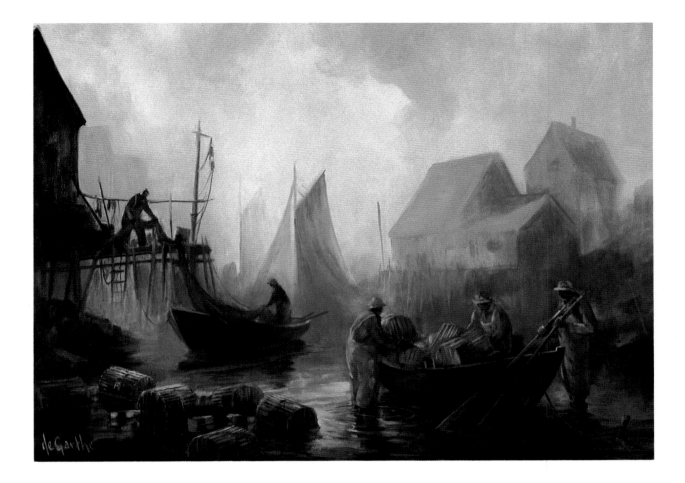

Peggy's Cove in Early 1930s
Oil on canvas, 1952. 65.1 x 90.5 cm. Collection of the Public Archives of Nova Scotia

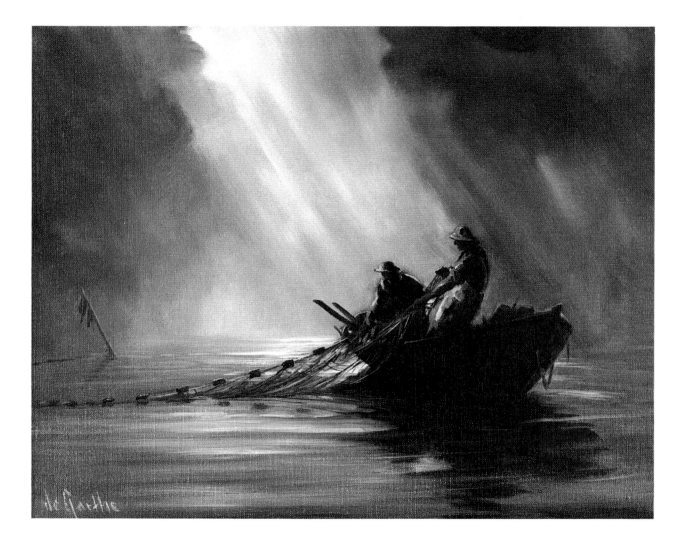

The Mackerel Fishermen
Oil on canvas, 1970. 45 x 60 cm. Collection of the Nova Scotia Power Corporation

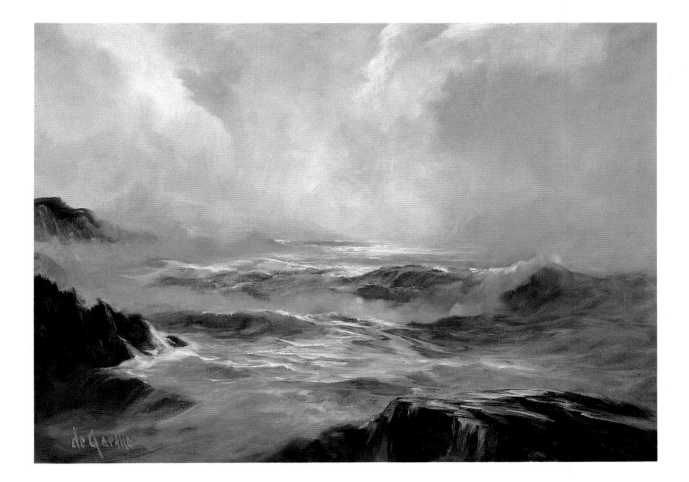

Morning Mist
Oil on canvas, c. 1968. 65 x 90 cm. Collection of the Art Gallery of Saint Mary's University

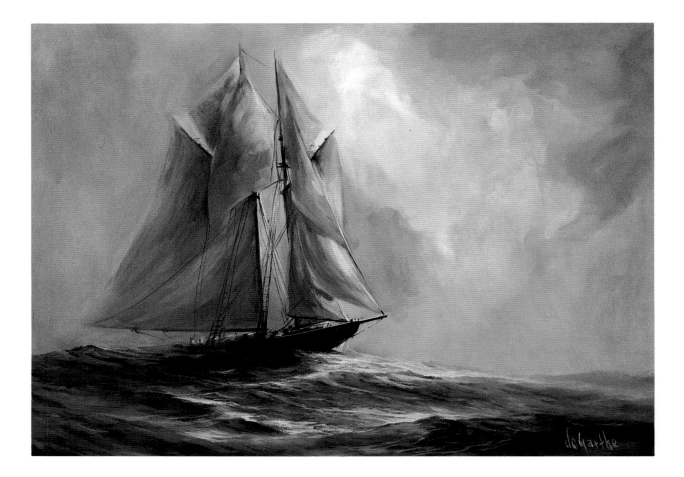

Bluenose on High Seas
Oil on canvas, 1956. 64.6 x 90 cm. Collection of the Public Archives of Nova Scotia

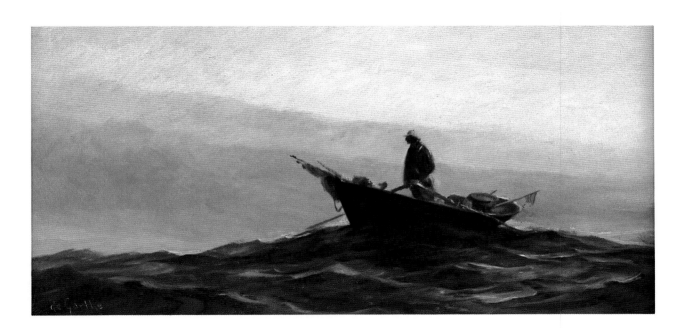

Looking for the Mothership
Oil on board, 1955. 28.5 x 59.5 cm. Collection of the Public Archives of Nova Scotia

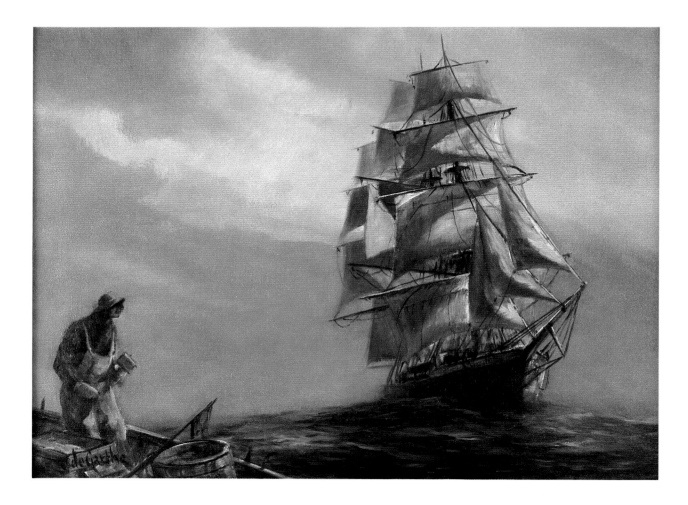

Chance Meeting on the North Atlantic
Oil on canvas, 1971. 45 x 60 cm. Collection of the Nova Scotia Power Corporation

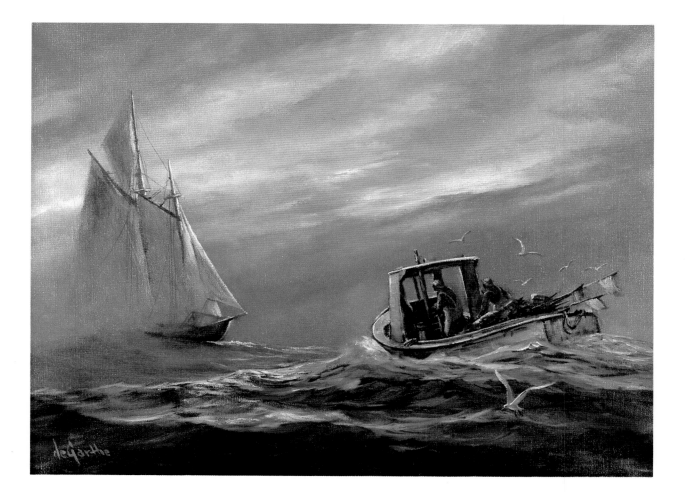

Cape Island Boat and Schooner
Oil on canvas, 1968. 45 x 60 cm. Collection of the Nova Scotia Power Corporation

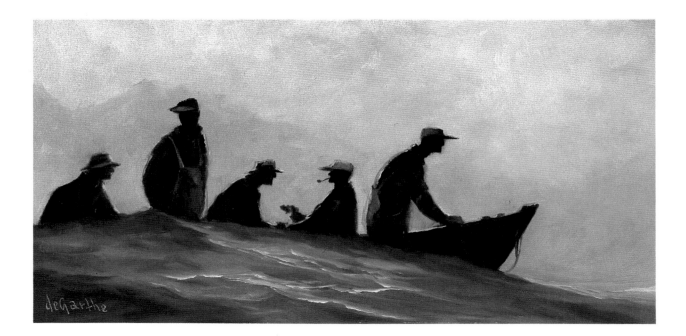

Five Men in a Boat
Oil on board, 1959. 29.5 x 59.8 cm. Collection of the Public Archives of Nova Scotia

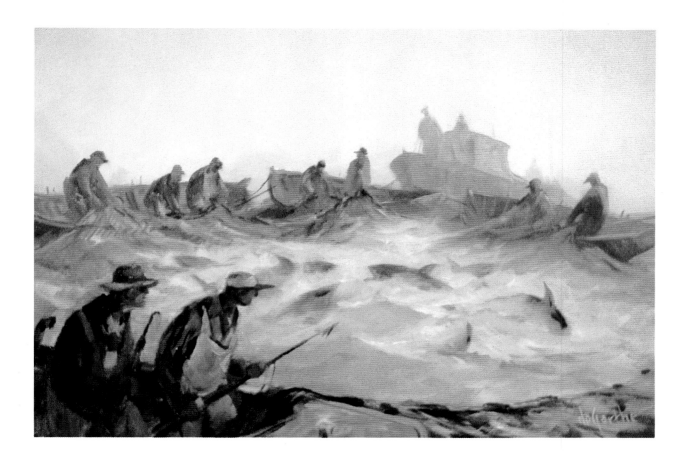

Untitled
Oil on board, c. 1970. 40.6 x 60 cm. Collection of Mrs. Agnes deGarthe

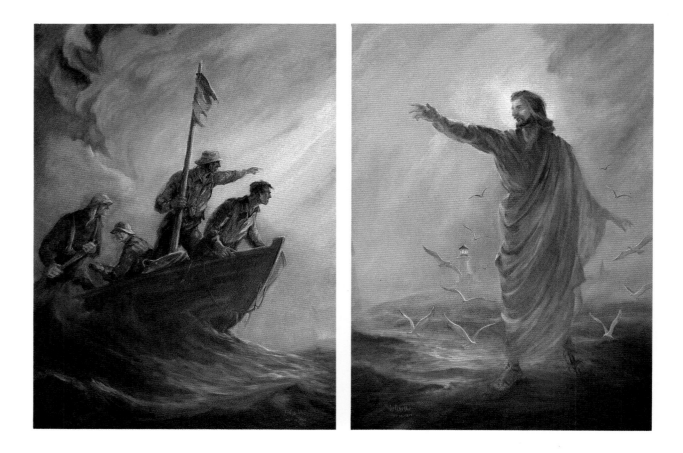

Untitled
Oil on canvas, 1963. Two paintings, each 136 x 209.5 cm.
Collection of St. John's Anglican Church, Peggy's Cove

Cranberry Cove
Oil on board, 1961. 45 x 30 cm. Collection of William and Isabel Pope

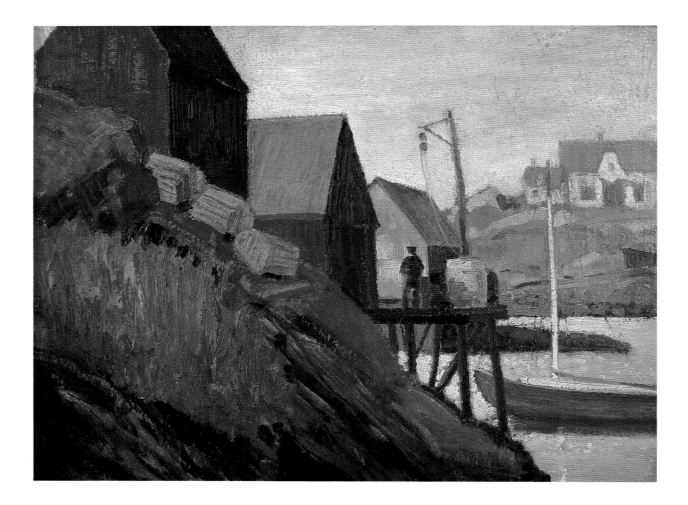

Peggy's Cove
Oil on board, c. 1940. 30.4 x 39.8 cm. Collection of the Art Gallery of Nova Scotia

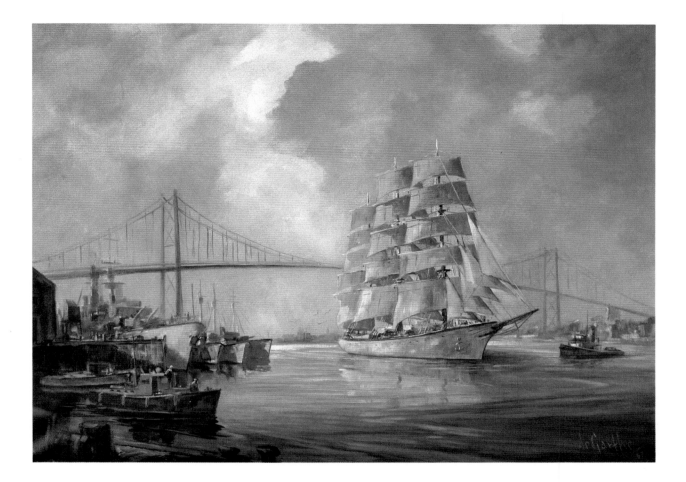

Full Bark "Libertad", Argentina, leaving Halifax Harbour
Oil on canvas, 1964. 65 x 90 cm. Collection of the Public Archives of Nova Scotia

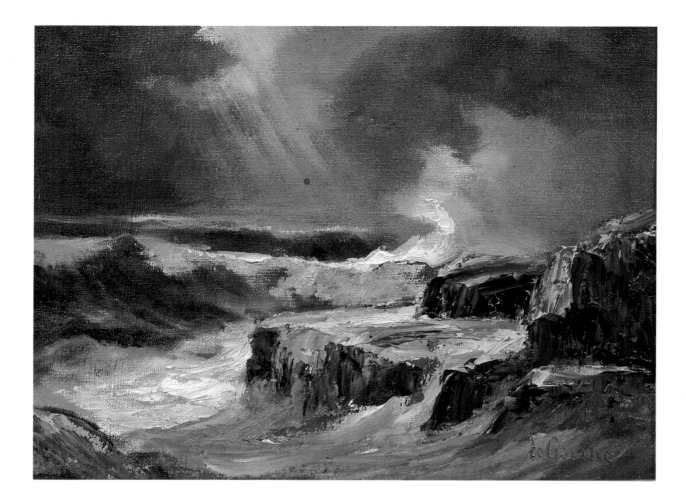

Untitled
Oil on board, c. 1968. 30 x 40 cm. Collection of Mr. and Mrs. Jack Campbell

4 Peggy's Cove

*L*et's quit!"

deGarthe credited these momentous words to his wife, she insists it was his idea completely. Either way, it had been on their minds for some time: for him, at the age of 48, to give up his prosperous commercial business, to resign existing accounts, move out of the orbit of the capital city and set up in a fishing village with a population of sixty people. Could he support himself as an artist? This was just one of many questions, such as: where would he exhibit his works and where would he sell them? In the same little village he lived in? The idea must have sounded preposterous!

Yet deGarthe and his wife knew exactly what they were doing. They had worked hard and they had been patient. They had been in the advertising business for twenty-three years. They had successfully run their own business and they had the additional income from their house building and selling projects. deGarthe was well known on the local art scene. Already he had done the first cover for the annual report for Nova Scotia Light and Power. He would do others periodically for the next twenty years. The company not only bought the paintings from which they reproduced the covers, they offered free reproductions to shareholders.

Thousands of people wrote in requesting them and they enjoyed an immense popularity throughout the history of that company. Even today these prints may be seen in frames hanging in the offices and homes of many Nova Scotians.

Peggy's Cove was changing. When deGarthe and his friends and fellow artists first started going there, there was no electricity and no indoor plumbing. The road from Halifax was so rough that it was easier and more practical for residents of the cove to travel to Halifax by boat. Everyone fished in those days. It was like a forest along the coast, each inlet and harbour being crammed with two-masted schooners and with the masts of flat boats and sloops. Roosevelt Hubley, whom I approached on a very windy bluff leading to a wharf, sheds and a brand new Cape Islander owned by his son, told me he began fishing at the age of twelve. He remembers starting out for distant fishing grounds many hours before dawn. Crude gas motors were just being adopted at the time and residents were used to hearing the unmistakable, loud and sputtering, put-put-put noise that signaled the departure of the local fleet, boat by boat. The noise carried for miles in the dead of night. When the ships reached open water, sails were often hoisted to save on fuel. At dawn the nets were set. Dories, transferred off the larger boats, were utilized for greater mobility. It was rough, dangerous work, manoeuvering a dory on the open sea. If it was foggy — which it often was — or if a line of the net tangled or broke off, the two boats could easily get separated.

deGarthe illustrated the aftermath of such a scene. He called the painting *Looking for the Mothership*—it is reproduced on this book's frontispiece. It shows a lone man standing upright in his dory, scanning the horizon. Clouds of fog move in on the boat, stranding the man and isolating him. The subtle sense of growing alarm, the realization of being cut off fron his companions and friends make this image very modern in its psychological impact and is a good example of deGarthe's ability to evoke an eerie atmosphere.

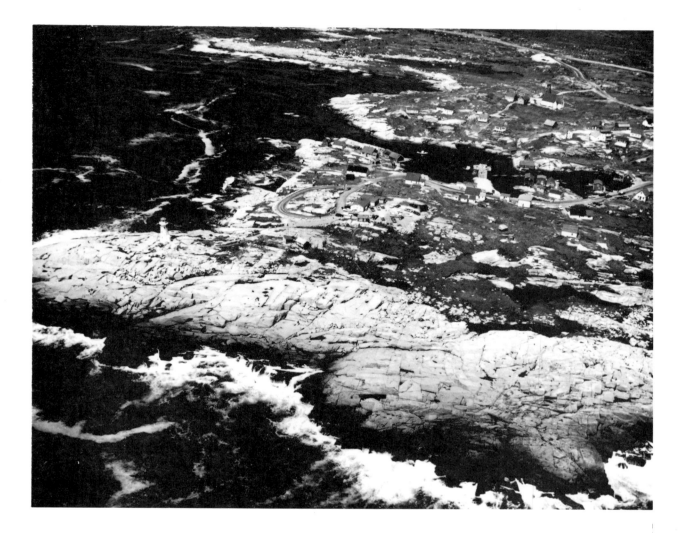

Aerial view of Peggy's Cove.
Photo by Nova Scotia Government
Information Services.

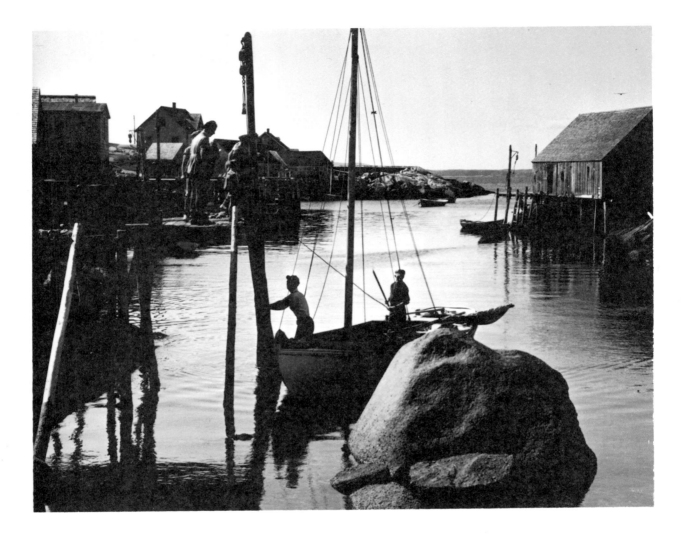

deGarthe and friends admire a local sloop.
Photo by Robert Norwood.

64

With the improvement of road conditions in the 1950s, Peggy's Cove saw a marked increase in incoming traffic and day visitors. Tourism began to rival fishing as the major industry. To this day, all residents are involved in the one business or the other, and usually in both, on a seasonal basis. deGarthe likewise had a vested interest in the cove's dual nature. He painted the local fishermen, their boats and nets, then he sold the pictures to tourists.

This selling involved a great deal of public relations: meeting people, answering their questions and being friendly. deGarthe was very good at this. He went out of his way to make himself available to tourists. He loved to chat and joke with them. People recognized this and appreciated it.

Among the humorous stories told, the following was related by Bill Norwood, brother of Robert Norwood. He drove a tour bus to Peggy's Cove on a regular basis. He remembers one day pointing out the key features of the villages along the shore to his group, when the trainee driver beside him, a hopelessly gullible and uninformed man, asked about two bags lying on a wharf.

"What are in those two bags there?" he queried.

Bill answered: "Why, I'm not sure, but I think it's salt."

When the man still asked: "And what do they use the salt for?" Bill couldn't resist answering: "They dump it in the ocean here twice a week — that's how they get the salt water in the cove." He figured anyone who couldn't put fish and salt together had it coming.

Now the news of this exchange spread so rapidly that by the time the bus, which made many stops along the way, reached the Marine Studio, the driver was taken aside by a mischievous deGarthe. The artist pointed toward a nearby wharf and said: "Can you tell me what's in those bags over there?" And that's how he let his friend know he'd heard all about the joke and thought it was a good one.

Many visitors who met deGarthe felt a genuine affection

for him. Once a very distinguished-looking professional man, with greying temples and bifocals hanging from a string around his neck, visited the gallery. deGarthe emerged, wet brushes in hand, to greet him. They chatted amiably for a few minutes, when out of the blue — in mid-sentence — deGarthe turned from his visitor and flicked his wet brush over the surface of a framed and finished painting, hanging with a price tag on the wall. deGarthe turned to his visitor with hardly a break in the sentence and resumed his conversation — with no reference whatsoever to what he had just done. He was almost certainly "putting the man on" — but what a light, carefree and humorous way he had! He was unusual, he was himself and people took to him.

The artist — he was like a king holding court — was regularly being featured in stories by visiting reporters. A local writer was given a tour of what she was to call deGarthe's "complex of buildings" in the heart of the cove. These consisted of his house and private gallery; across the street a garage with a painting studio upstairs; and down the road, the red gift shop known as the Marine Studio, which, despite near wreckage in a hurricane, is still open for business.

Under the heading: "Crossroads of the World: Peggy's Cove, Home of Famous Artist," a reporter from the *Boston Sunday Globe* wrote:

> A dynamic personality, Mr. deGarthe has turned his boundless energy to the preservation of the character of this little community and to helping visitors to understand and enjoy it. His seaside studio, where the door is always open, is at the junction of three roads... it is an information bureau, a fount of philosophy, a rendezvous for visiting celebrities, an art school, a museum and an arena for the discussion of almost any subject within imagination.

Because the group which congregates in deGarthe's

studio often includes visitors from many countries, he hung a new sign this summer. It reads: "The Crossroads of the World." "This is going to stir some comment," he says, tongue in cheek.

When the deGarthes moved to Peggy's Cove, they worked hard to fit in with community life. The affability and good humour of the artist, combined with the practicality, openness and generosity of his wife, soon broke down all barriers. They hosted parties at which everyone in the village was invited. There were bonuses for themselves as well. They bought their fish fresh from the men in the village. (Before going south in the winter, they would hang the fish to dry in their backyard from a clothesline, salt and load them into the trunk of their car; all winter in Florida, they would be eating the fish of Peggy's Cove.) deGarthe in a moment of great enthusiasm bought a sloop, which he tied to the wharf next to his studio. He occasionally took it out into the bay, but he had little time for recreation.

Shortly after 8:00 a.m. each day, Bill and Agnes would climb the steep winding hill to the postmaster's house, a small but stately two-storey house with a central dormer window, located within sight of the lighthouse. Louis Crooks was the postmaster and the villagers would often arrive before he'd had a chance to sort the mail. It would be lying in a big heap on the kitchen table next to the woodstove and beside the giant geranium in the window. The neighbors would wait their turn while it was sorted out. (Tourists, incidentally, entered from the front door and were served in the living room, residents entered from the back door and were served in the kitchen.)

deGarthe heard all the local news and learned a great deal about the village on these visits. He became friends with Mr. Crooks, a man with a wide store of knowledge and an acute sense of history. He was also a man of tremendous personal integrity and was looked up to by all in the community. His

deGarthe's first book was published in 1956, the year after he moved to Peggy's Cove.

father, Wesley Crooks, had been the oldest serving postmaster in Canada when he retired at the age of 99.

It may be that every small village has its own "wise old man or woman," the custodian of its oral history and guardian of its traditions. In Peggy's Cove, this man was Louis Crooks. From him deGarthe learned many details of the history of the village, information which he transcribed into a little booklet called *This is Peggy's Cove*. The published book was beautifully illustrated with meticulous pen and ink drawings and designed with an old-fashioned flourish that accurately reflected the style of deGarthe's commercial art: simple, elegant and clean, leaning toward the picturesque and the nostalgic, with the occasional humorous, dramatic or anecdotal touch. It went over big with tourists and is still in print—no mean feat for a book that is 34 years old.

In part the book was written for tourists; in part for the author himself, who shared with the cove's many visitors a fascination for a place he would call "the Pearl of the Atlantic."

I remember well the blistering cold day Roger Crooks, the church custodian, showed me the unheated interior of the small, beautiful church in Peggy's Cove. He pointed out the woodwork on the walls and mentioned details of the building's construction. Then he said, half apologetically, that he was no authority on these things, adding: "*Now deGarthe was the man* who could have told you *all* about this church — where the wood came from, who the architect was. He had a terrific curiosity, he was interested in so many things, and of course he knew a lot about Peggy's Cove."

Among the many queries that tourists would put to this genial giant, one of the most common was: how did Peggy's Cove get its name? Here was a question that unloosed deGarthe's imagination; it intrigued him and it intrigued others as well. So an answer was provided — or rather, two answers. I reproduce them as they appeared in *This is Peggy's Cove.*

HOW PEGGY'S COVE GOT ITS NAME

Many have asked: "How did Peggy's Cove get its name?" There are two versions in existence and the first has more generally been accepted, because of its romantic and dramatic appeal to most people. The story goes that a schooner was wrecked on "Halibut Rock" off the Lighthouse Point, in a "Southeaster", in sleet and fog on a dark October night. The ship ran hard aground and with high waves washing her decks, some of her crew climbed to the masts, but the waves washed them into the boiling sea. Everyone on board was lost except a woman, who managed to survive the turbulent seas, swam ashore and was finally rescued by the people on the shore.

Her name was Margaret, and she married one of the eligible bachelors of the Cove. The people from near-by places used to come and visit Peggy of the Cove, and before long they began to call the place Peggy's Cove. How true this story is, no one knows, and there are no documents available to confirm or refute it.

In the second version, perhaps not so romantic, but more logical, Peggy's Cove, being situated at the entrance to St. Margaret's Bay, was shortened from Margaret's Cove, to the more intimate name of Peggy's Cove, a name world famous now for a place of scenic beauty, where tourists gather from far and near.

Page facsimile from This is Peggy's Cove

It was the first version or legend of the shipwrecked Peggy that stuck in deGarthe's mind. He increasingly worked it with various elaborations into interviews with visiting reporters. Some of these reporters would print the legend of Peggy with a cautionary preface, others would print it exactly as they heard it—a piece of indelible and irrefutable history.

When I asked one resident and neighbour of deGarthe's about the story of the shipwrecked Peggy, he told me: "I was born here, my father was born here, my uncle was born here—and none of us ever heard of it. With a thing like that—a legend—it gets passed down, someone tells someone else and that's how you keep it going. You can't keep it secret so don't you think we would have known?" I asked him where he thought the legend came from. "deGarthe made it up. He had to, no one else ever heard of it!"

Though little known, there was a basis to the legend.[1] deGarthe expanded the story and promoted it, pushing this obscure tale into the forefront of the cove's history. For one thing, it injected a little colour into the village's past and added a romantic figure to its history. But there was more to it than this.

Striking similarities exist between the legend of Peggy and deGarthe's own life. It is the story of an outsider's dramatic appearance, her marriage and integration into the life of the community. By attracting visitors from outside, she causes the fame of the village to spread to such an extent that the cove is named after her. deGarthe is also an outsider, a foreigner who makes his dramatic appearance in the village. He is also accepted and integrated into village life, he also attracts visitors and helps spread the fame of Peggy's Cove. For deGarthe then, Peggy is an alter-ego as much as a mythical heroine. It explains his fondness for her as a subject. He would do a painting and three statues of her in all. In the first of these, she is presented as a barefoot and rustic-looking young woman. A faraway look in her eyes suggests she is scanning a

distant horizon, a shore unseen by the rest of us. She is a prophetess, emerging from humble roots to provide guidance to the men who spend their lives in elemental battle with the sea. Later, in the design for the ambitious Fisherman's Monument, deGarthe would make Peggy the central figure.

In developing and enlarging the legend of Peggy, deGarthe drew from some of the deepest and most ancient feelings that people have about the sea and its femininity. One of the great myths of the Greeks concerns the birth of Venus, who rises mysterious and beautiful from the foam of the sea. She is a goddess born in the sea. The widely travelled deGarthe

Three versions of Peggy, all by deGarthe. The first shows her as human; in the latter two she is more of a goddess or nature deity. Each work gets increasingly simplified and less realistic.

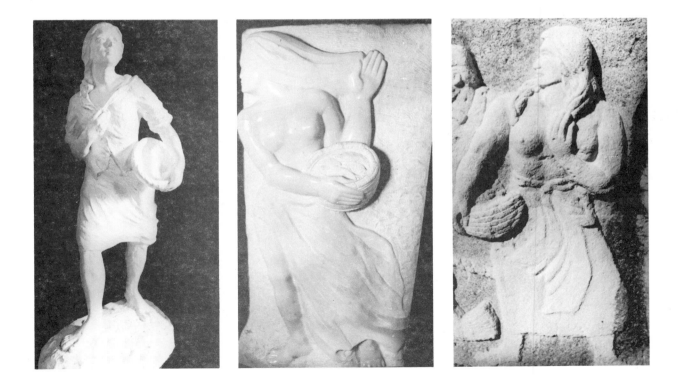

Detail of The Birth of Venus *by Sandro Botticelli.*

(he spent four winters in Italy) would no doubt have been familiar with Sandro Botticelli's unforgettable image of Venus' birth. This famous Renaissance mural depicts a sensuous and dreamy-eyed woman emerging from the sea, standing on the shell of a scallop or oyster—she is literally a pearl.

Peggy likewise emerges out of the sea; the shipwreck she experiences is a kind of death—all the other passengers died—and by reaching shore, she is reborn. But what does it mean to be born in the sea? One might say, she *is* the sea, but in a human guise. Edith Hamilton gives this description of Venus: "The goddess of Love and Beauty who beguiled all, gods and men alike; who laughed sweetly or mockingly at those her wiles had conquered."[2] She is a seductress; in some cases dangerous. The sea has been referred to as a woman so often by poets and writers that the association is commonplace. In *The Old Man and the Sea,* Ernest Hemingway made a distinction between what the central character called the sea: "la mar," an affectionate expression in Spanish, and what the younger fishermen called the sea: "el mar", a masculine term suggesting an opponent or enemy or place. In contrast, wrote Hemingway, "the old man always thought of her as feminine and as something that gave or withheld great favours."[3]

We are all aware of the mysterious attraction and allure of the sea, its bewitching quality. In the legend of Peggy, her chief characteristic is her ability to attract people to her, she draws people to the cove, why is never explained. Perhaps she is Venus; perhaps she is an embodiment of that mystery and intangible spirit of life which to many people, artists as well as laymen, is found in close proximity to the sea.

*W*ell known as a painter, deGarthe was also a teacher of wide experience. He instructed students in commercial art at the Nova Scotia College of Art, he offered recreational classes through the YMCA, he led a week-long workshop once a year

at various points throughout the province. He once conducted a two-day workshop for the wives of the Canadian premiers during a national first ministers' conference held at Digby Pines, Nova Scotia. He even gave a demonstration to a Halifax reporter, who under his guidance produced a drawing that she said later was not for sale at any price.

Some former students remember him as being a bit impatient, but different students have different memories. Precocious pupils thought he was great, he just left them alone to develop as they pleased. Others needed all the help they could get. One lady still recalls him walking around her easel to view the work in progress and exclaiming: "What went wrong here!" He was sympathetic, but he didn't lie. Of all his qualities, the general consensus portrays a wonderfully uninhibited man. Their first impression of him was of an actor performing for their benefit. He was entertaining and he made painting fun.

"I don't know what kind of instruction the students got," Bob Chambers told me, "but they got great entertainment! Oh, the students loved him . . . he used to stride around their easels, saying, 'Very good, very good!' This was his favourite gesture, [forming his thumb and forefinger in the shape of an 'O'], he'd punctuate his sentences with it—'Okay! Okay!' — he made you feel like you were going to be Rembrandt in two weeks!"

His advice to young artists was expressed in this manner: "You have to be happy when painting. Your moods show in your production. You should acquire a feeling of enthusiasm." deGarthe sometimes tried to shock others as a way of loosening them up and making them see things in a fresh way. He helped liberate his students. He often told them to use the largest brush possible; this prohibits fine detail and forces one to work more freely. Many students have a fear of the blank canvas confronting them, they find it intimidating and they don't know quite where to start. deGarthe had them stabbing at it ruthlessly and quickly got them over this.

A prophetess of humble origins — deGarthe's first statue of Peggy of Peggy's Cove.

Being a convivial man, the teacher liked to socialize with his students. He would host parties at his home or join older members for a drink after class. He was an insatiable dancer and conversationalist. He excelled at parlour games. He used to throw himself into them with the same energy that motivated his paintings. On one occasion, while acting out a charade, he got down on his back on the floor—the word he was acting out is completely forgotten—possibly a fireman crawling through a window. On other occasions he would tell semi-mystical stories, much of it fantastic and yet he could dissolve listeners into tears. One student paid him back in kind. At the end of a workshop, he acted out a skit lampooning the master. The master's reaction? Sheer delight! He and the student, René Barrette, became close friends and eventually worked together on the Fishermen's Monument. René wrote me: "What distinguished our relationship was that we could always make each other laugh."

One feature of the man and teacher that was undeniable was his feeling for nature. On the week-long camps he would have his class out most days painting after nature when the weather was good and often when the weather wasn't good. In his book, *Painting the Sea,* deGarthe has this practical advice:

> It all sounds so easy, but there are some trials and tribulations involved in painting by the sea. A few hints . . . first of all, dress warmly and wear shoes with rubber soles. Your equipment should be as light as possible. Sometimes, I don't bother with an easel, but if you must, use a light one.

More than he could teach them, they would have to see and experience for themselves outdoors. deGarthe, famous for his long walks in the early mornings and evenings, was himself a keen observer. This is his description from a radio speech:

> This whole Minas Basin area is one of remarkable beauty. In addition to the colour contrasts mentioned,

A demonstration during the Premiers' Conference held at Digby Pines in 1977. The woman on the right is Vicki Lynn Bardon of Suttles and Seawinds.
Photo by Doris Saunders-Hynes.

it has certain very striking natural features. On the north shore of the Basin lies Economy Point and west of it the Five Islands (there are really six, but I suppose the big one doesn't count.) The islands owe their existence to a line or dyke of black volcanic rock, so that they are partly red and partly black. They make very interesting shapes and the westernmost has a hole right through it.

I have sketched the islands under varying conditions of weather—black or purple above vast stretches of red mud when the tide is out, red with wonderful silvery reflections on a bright day with the tide in, black and forbidding under lowering skies under a storm. The changes are endless and delightful. Similar black rocks appear again further along the coast at Advocate and on the opposite side of the basin. If you look closely at Blomidon, you will find it black above and red below. The red shores are smooth with rounded contours, for the sandstone is soft, but the black rock is hard and brittle and splits and cleaves, leaving jagged edges. It is these properties that give us the long high curving headland and the dramatic end of Cape Split. Its name describes it better than words can.

Teacher and students; a YMCA class from 1952.
Photo courtesy of Margaret Pope.

A former student, François Delisle, spoke to me of his appreciation for what deGarthe had taught him. He credits the marine painter with freeing him from the slavish imitation that grips so many amateurs. deGarthe "liberated" him—the word came up repeatedly—and helped him to find a personal style that he felt comfortable with.

Personal style is very important in art, it has a lot to do with self-confidence and a clear sense of purpose. For a viewer to approach a painting and exclaim, "That's a deGarthe!" they must make a close association between the man and his work; the work carries or conveys the artist's personality and vision of the world. It is difficult to define a "vision" that is unique

and different from everybody else's. Invariably the more clearly an artist can differentiate *his* vision from all who have gone before him, the more successful the artist will be. When deGarthe said: "The misty quality of my painting is well known, it's my signature, I don't even have to sign the painting—it's a deGarthe!" this is what he meant, he had found a unique style.

But in order to have a true style that will have an impact on people, there has to be some meaning behind it, a purpose or message being communicated. deGarthe was aware of this and when he taught his students, he used to stress the mental aspect as much as if not more than the technical part of the painting process.

deGarthe viewed painting as an activity accessible to

deGarthe during a workshop at Balantine's Cove in 1978.
Photo by François Delisle

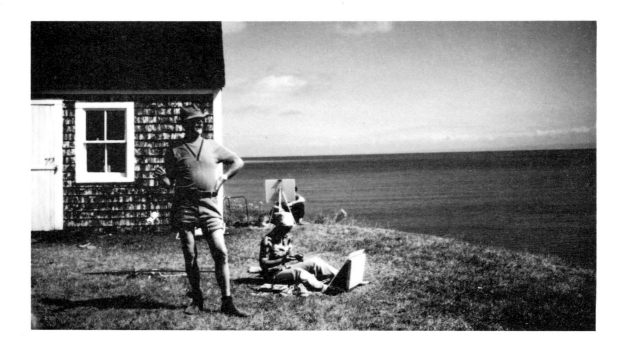

anyone, regardless of his or her talent. He broadcast a lecture over the radio in the early fifties that began like this:

> We all have our little worries and it is important
> that at times we forget these worries. For if we don't,
> at times, get rid of them, they will get rid of us . . .
> my own recreation is painting in watercolours and
> it always surprises me that more people don't try it.
> Of course people will tell you that they have no talent
> for that sort of thing—which is nonsense. Naturally,
> there are degrees of talent. You mustn't expect to
> produce masterpieces. I certainly don't. But I can think
> of no other recreation which gives so much fun with so
> little trouble.

In this speech, one senses why he was such a successful teacher. He was encouraging and enthusiastic without being overbearing and critical. A motto of his that a neighbor remembers clearly after many years was: "Look for the good!" in art, in people, in life in general. To deGarthe, all experiences were opportunities to live more richly, more fully; the outcome was not nearly so important as the experience and process of living itself. From the same radio speech, he said:

> But landscape was—and remains—my first love.
> It combines the thrill of discovery and the delight
> of the out-of-doors with the practice of one's art
> upon objects which remain mercifully still while you
> try to transfer them to paper.

> Perhaps I can best convey all this to you by the
> story of two golfers. One of them always hit his ball
> right down the middle of the fairway. He was
> accustomed to reaching the green in two and holing
> his putt in one stroke. He made low scores. His
> companion was erratic and happy-go-lucky. He strayed
> from side to side of the fairway and did not mind

greatly if he had to pick up his ball and never reached the green at all. But he claimed that he got far more interest out of the game. Robins flew into the bushes ahead of him, snakes wriggled away from his footfall, jays squawked and squirrels chattered at him, he even found his way into farmyards and back gardens and discussed the crops and the weather with their owners. It has always seemed to me that this kind of existence is preferable to merely bowling along the centre of the highway of life in a large automobile.

Quality of life was important to deGarthe. It explains partly his move to Peggy's Cove and his great attraction for the days of the grandbankers and fishermen of old. In the quoted illustration, he contrasts the well-trimmed and familiar fairway with the unkempt peripheries, full of wildlife and leading to chance encounters with interesting people—clearly the path that he himself preferred to follow.

His paintings would evoke this same theme, which stems from the earliest of times. Joseph Campbell in *Creative Mythology* is very fond of quoting the phrase of "knights, travelling from the known to the unknown, entering the forest *there where they saw it to be thickest.*"[4] deGarthe himself was so attracted by this image or symbol of venturing knights that he composed and painted an enormous work, depicting "A Scene from the Crusades."

In his personal life, there were to be many unkempt paths and many chance encounters. One can imagine his passport stamped with cities around the world: Copenhagen, Cairo, Montreal, Miami, Moscow, Morocco, New York, Athens, Amsterdam, Rome, Paris, Key Largo, Rio de Janiero, Mexico, Madrid, Nairobi, Helsinki, Stockholm, Lisbon, London, Florence and Berlin.

Some of deGarthe's trips combined business and pleasure. In Paris and Rome he enrolled in prestigious academies where

Galapagos Islands, 1974.

he studied painting and life drawing. Near Pisa, in Pietrasanta, he signed on with a major sculpting studio and worked there for several months over a three-year period. He visited the Prado, the Louvre, the Sistine Chapel and the Parthenon, as might be expected. More unexpected were a safari tour of Africa and a similar expedition to the Galapagos Islands.

These latter trips reflected deGarthe's interest in those "unkempt peripheries" with the wriggling snakes and squawking jays. Both the Serengetti Plain in Africa and the Galapagos Islands represent frontiers, last holdouts from the reaches of Western man.

Africa, 1972.

One of deGarthe's most important trips was to visit his family in Finland in the early fifties. It was during the summer Olympics held that year in Helsinki. (The symbolic value of hosting such an event cannot be underestimated. One might compare the Korean Olympics of 1988, so important to that country's emerging economy, national esteem and cultural pride.)

deGarthe's wife accompanied him on this trip and remembers vividly the long summer nights that never got dark. "We could never get to sleep," she said. Was it the light, or the excitement of being back? deGarthe revisited his childhood haunts, giving his wife a tour of the fishing districts, which held a special interest for them both. The painter took advantage of quiet moments to slip off with his father. They would fish in the harbour below the family home and there reflect on the changes that had overtaken them and the world around them.

deGarthe's family was important to him throughout his life. He and his brothers would visit whenever possible—a rendezvous in Paris, a trip to Expo in Montreal—as well as exchanging a wealth of correspondence, all of which was kept and stored with meticulous care. But as strong as his feelings were, especially those stirred up by the reunion in Kaskö, the painter knew that his home now and for the future was in Peggy's Cove, Nova Scotia.

5 Greenbacks and Grandbankers

Everyone remembers visiting deGarthe. For most friends and acquaintances, a trip to Peggy's Cove would be incomplete without seeing the resident artist. Bob Chambers was one of many who would occasionally drop into the painter's studio. Often they would sit and chat and then out of the blue deGarthe would say, "Do you want to see something really good?" He would walk over to his desk or easel and, beaming, hold up his latest production. "Nothing shy about Bill," said Chambers. "Not backward at all." Was he a good salesman? "Oh, terrific!" This answer became the unanimous response from all sources.

Ian Muncaster, owner of Zwicker's Gallery in Halifax, recalled deGarthe telling of his success. The scene: Florida, it's winter time, but warm. deGarthe is outside in his shirtsleeves and beret, standing by his easel, working. The ocean stretches before him. An elderly couple saunter by—this is one of the major retirement havens in the world—he makes conversation. More people come up.

Detail from sketch, (charcoal on paper, 1963)
for the church mural in Peggy's Cove.
Agnes deGarthe collection.

He is regaling them with stories—treetop restaurants in Africa, watching lions quench their thirst at a pool below over breakfast, jumping out of dinghies into shallow water, climbing to the rocks nearby as a group of seals slip into the breaking waves. By the time he's finished, both his canvas and the stories, there's a respectable crowd all clamoring to buy the work of this distinguished artist.

A resident of Peggy's Cove showed me a small painting of deGarthe's he'd bought for $25. deGarthe had just set up at that time and sold all his pictures for $30. Residents got a discount, as did students of his art classes. Elizabeth Pacey, now a well known writer on the Halifax scene, remembers fondly the occasion when her father bought a small deGarthe painting for her birthday. deGarthe asked how old the child was. "Twelve," he was told. "Twelve dollars for the painting," he set the price. Not the most orthodox way of doing business; it was charming and had a personal touch to it. Even representatives of huge corporations like Nova Scotia Light and Power loved dealing with him. Their transactions would turn into highly enjoyable social visits.

A student asked deGarthe how he set a price on his pictures. The instructor's advice was to be realistic, to start out with a low price, but when there is more demand for your pictures than you can produce pictures for, you raise your price. But he said, there is one thing a painting can never be— discounted. Once a picture's price is determined you can never go back and lower the price. If this contradicts some of his earlier practices, it reflects a later viewpoint when his paintings were fetching hundreds and thousands of dollars each.

However, not all of deGarthe's pictures were for sale. If, for example, his wife Agnes especially liked a picture, he would give it to her and it would become her picture. In their gallery, they displayed many pictures, including some of their own personal favourites. One day a man came into the shop and after standing in front of a painting for some time, asked

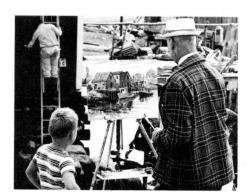

On the wharf in Peggy's Cove.
Photo by Nova Scotia Government
Information Services.

deGarthe the price of the picture. deGarthe answered that it wasn't for sale. The man obviously considered this a ruse and declared with some indignation: "Look, I'm just a simple lawyer from Philadelphia and I happen to like this picture. I know everything has a price; what's yours?" deGarthe answered: "I'm just a simple artist from Nova Scotia and that painting's not for sale."

Robert Norwood's son, Ned, a filmmaker employed by the province, became a great friend of deGarthe's. He remembers frequent visits with his father, taking photographs or shooting film. deGarthe would accompany them onto the rocks and often cooperated in their picture making. He suggested ideas and helped them to pose some of the men working on the wharves.

Ned approached deGarthe to feature in a segment of a film called "Artists" to be distributed by the provincial tourism agency. He explained: "On film, you have to repeat an action over and over. Bill never complained, he just did it. He loved whatever he did, he was a great guy to work with. I told him: 'This is great advertising, this film will be shown all over. Tourism will take it into the States. You don't know how many people will see this.' He looked at me like I was a salesman going on and on after the customer has already bought. 'Why do you think I'm doing it!' he said. He understood a lot about selling. He was a commercial artist before he got into painting. His painting was always commercial. Like me—I make films that people pay me to make. But I always try to make them in a creative way, I try to express something of myself in them . . . You have to understand, Bill was a man whose formative years were during the Depression. Hell, no one talked about being commercial then! You worked to support yourself and it was something you were proud of, being self-sufficient. There weren't any government grants back then. If you couldn't do it

You are cordially invited to a Sketching & Painting

EXHIBITION

by deGarthe

at the MASONIC HALL

NOV. 24 to NOV. 29

OPEN FROM 10 A.M. to 9 P.M.

A poster for deGarthe's first one-man show in Halifax.
Agnes deGarthe collection.

yourself; you wouldn't think any more about it, it wouldn't get done. And when you did something, you were proud of it."

deGarthe had several public exhibitions of his work. A worker at one gallery said they never received so many enthusiastic comments for a single show and at his first solo show in Halifax he sold every painting. In all he had one-man shows in Halifax, Fredericton, Montreal, Toronto, New York, and in Florida and the British West Indies. He exhibited with the prestigious Royal Society of Marine Painters in London, England. However, deGarthe never had a retrospective showing of his life's work and for a painter of his stature, he had less shows than might have been expected. He also had less need for them. The main reason was simply that he served as his own dealer. There was no middle-man extracting commissions on sales. At the start of his career, this may have been due to necessity, due to a lack of dealers and outlets in the province, as well as being the wise economy of a man proud of his hard-won independence. deGarthe also recognized that he was the best salesman of his own work.

Setting up a gallery in Peggy's Cove goes against all the norms of the art marketplace, which invariably bases itself in a cultural centre, usually the capital city or the seat of political or economic power. The advantage of Peggy's Cove as a marketplace lay in the volume of people coming through the village. Usually these were people on vacation, relaxed and open to new experiences. Except for a few gift shops there is little commercial business catering to these visitors. deGarthe's shop, located on the main road, was in an ideal position. Here the buyer could meet the artist, talk to him freely, ask any question he wanted and get the artist's own evaluation of his work.

deGarthe's whole approach was a populist one. Anyone at all, no matter who you were, if you only took the trouble to go to Peggy's Cove, could be assured of the warmest and friendliest reception. deGarthe wanted people to like his paintings and he got the proof, time after time, that they did.

Why were deGarthe's pictures so popular? When I put this question to Bob Chambers, he answered with no hesitation: "Oh, it was the subject matter! And he painted in a way, in a style that people understand and like. He wasn't far out." deGarthe was asked in an interview for a Florida magazine about his subject matter. He answered:

> If you look at my paintings, what am I recording? A passing era of the sea . . . If you know the Grand Banks and the dory men, that is an era of the past. You can't get the men into the dories anymore and the schooner has disappeared except for a few preserved for the tourists to see . . .

As for the demand for his pictures, he said:

> People are very nostalgic when it comes to the sea. The people of Boston, Gloucester, Nova Scotia know the sea. You mention a schooner and perhaps their grandfather sailed such a ship. This nostalgia is passed down.

For people from the Maritimes and New England our association with the sea is closely bound up with our history and geography. "The Age of Sail" is a common term we use in connection with what we now regard as a golden age when shipyards scrambled to keep up with the commissions to build new vessels and native captains and crews sailed these ships around the globe. They played an important role in bringing men to the historic goldrushes in Australia and California. If we compare ships to cars, then Lunenburg and Boston were the Detroit and Tokyo of the 19th century. The schooner *Bluenose* is now a national emblem, gracing the Canadian dime. Two of Nova Scotia's greatest heroes were Joshua Slocum, the first man to sail around the world alone (Slocum once wrote: "My father was the sort of man who, if wrecked on a desolate island, would find his way home if he had a jack

knife and could find a tree."[1]) and Donald MacKay, the master builder of clipper ships.

But the appeal of the sea is not confined to Nova Scotia. It is a universal phenomenon attested to by poets and artists alike. Coleridge wrote:

> We were the first that ever burst
> Into that silent sea.[2]

He suggests a state of existence before the fall of man. To most of us, the sea is invigorating; in contact with it, a man becomes healthy in body and spirit; beyond that, there is a mystical attraction that is hard to explain, as Herman Melville notes:

> Why is almost every robust healthy boy with a robust
> healthy soul in him, at some time or other crazy to
> go to sea? Why upon your first voyage as a passenger,
> did you yourself feel such a mystical vibration,
> when first told that you and your ship were out of sight
> of land? Why did the old Persians hold the sea holy?
> Why did the Greeks give it a separate deity, and own
> brother of Jove? Surely all this is not without
> meaning. And still deeper the meaning of that story of
> Narcissus, who because he could not grasp the tor-
> menting, mild image he saw in the fountain,
> plunged into it and was drowned. But that same
> image, we ourselves see in all rivers and oceans. It is the
> image of the ungraspable phantom of life, and this
> is the key to it all.[3]

Two elements stand out in deGarthe's prolific outpouring of canvases (by his own estimate he produced 75 to 100 paintings a year): the depiction of work and kinship with the sea. The painter saw his own work ethic reflected in the fishing industry, a notoriously dangerous and physically demanding occupation that could be portrayed in stirring and dramatic terms. Fishermen also possess semi-nomadic dispositions and

Charcoal Sketch.
Collection of Agnes deGarthe.

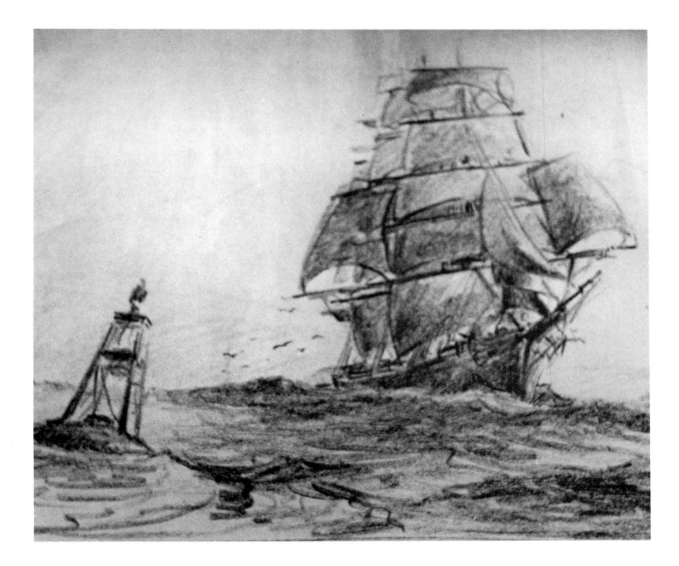

Sketch, charcoal on paper
Collection of Agnes deGarthe

87

Beacon of the North Atlantic,
unfinished canvas reproduced in
Painting the Sea.

the resourcefulness and adaptability necessary to those working with the sea, qualities that echo the characteristics of heroes down through history.

deGarthe drew and painted these fishing folk, villagers and dory men in a style that crossed Michelangelo with Lil' Abner—heroic but folksy, the figures being a little too loose and gangly to satisfy the requirements of how the Greeks envisioned their gods. Yet, though the figures are painted with remarkably little detail, they still come off with an idiosyncratic, swaggering insouciance that surely reflects their creator's own—their long-peaked caps and corncob pipes are beautifully matched by square-jawed chins and hawk-like noses.

These men frequently appear in groups, hauling or repairing nets, which, as symbols, carry the same Christian overtones as do Millet's "Gleaners" or Van Gogh's "Sowers".[4] The nets can yield plentiful or modest catches, depending on how they are set. In the same way, a man's life can be rewarding or empty, depending on his goals and his methods of achieving them. Though sometimes these things are beyond his control.

When I asked a former student of deGarthe's if she thought he was religious in any way, she said off the top of her head: "If anything, he is sacrilegious!" No one would accuse deGarthe of being the model church-goer. Yet he would often speak of God and he surely believed in God. In many ways, he had his own theology, the truest indication of which is in his paintings. In canvas after canvas, we see the spray of a wave catapulting off a rocky breakwater. The lasting impression is one of energy and power, a contest of water against rock that must have existed before man and will undoubtedly outlive him. Many of these waterscapes have an appearance of the beginnings of the world. They are prehistoric and ripe with birth. Here we encounter a mood of other-worldliness; and when men make their appearance, we have the sense that they are seeking their inner selves.

FLORIDA, 1965

Sketch, charcoal on paper.
Collection of Agnes deGarthe

Many Christian symbols and ideas are related directly to the sea. The major activity of Christ's ministry revolved around the Sea of Galilee and four of his disciples had previously been fishermen. The phrase "fishers of men" is a famous reference to the ministry of Christ. The almost hallucinogenic image of Christ walking on the surface of the sea is one of the most haunting of his miracles and finally, the story of Jonah, spending three days and nights in the belly of the whale before escaping with his life, is widely taken to prefigure the resurrection of Christ.

deGarthe painted two religious murals, plus many studies and smaller canvases, showing Christ interacting with fishermen. In the mural painted for the church at Peggy's Cove, he surrounds the figure of Christ with twelve seagulls. The gulls stand for the disciples, as well as referring to the dove and the Holy Spirit. Local legend has it that seagulls embody the souls of men lost at sea. There is something particularly apt about this tranference of "lost men" to pure spirit, whose purgatory is endless soaring, scavenging and flight.

The most marked and common apparition deGarthe utilized to give an other-worldly effect was the ghost ship: a schooner emerging out of heavy fog to the amazement of fishermen working in a more modern era. The encounter of a vessel from the past with her modern descendant sets off a shock of denial — *that can't be so!* When one considers the legend of a famous ghost ship— such as *The Flying Dutchman,* an unlucky ship doomed to roam the world without ever landing — it enters the domain of the supernatural and the eerie. One can see the appeal of such a legend to the uprooted Finn, with his own experience of wanderings.

deGarthe's ghost ship pictures also contain the spiritual contrast of the mundane, concrete and realistic foreground figures with the supernatural or spectral vision of the distant, foggy, almost immaterial, and above all, majestic ship. It suggests the ultimate sea journey, a passage from life to death.

deGarthe achieves the same effect, the sudden appearance or presence of the supernatural in the natural world, by his highly symbolic use of surface atmosphere. Fog banks, clouds and mists are manipulated like a stage curtain to alternately reveal and conceal dramatic tableaux. The artist consciously developed this effect. About the misty quality of his painting, he once said: "The people are seeking it. It's my signature. I don't even have to sign the painting, it's a deGarthe!"

This elusive quality did not always come easily to him. A breakthrough painting for deGarthe—and one he would never sell—was "Out of the Mist." The painting is simplified, a condensed and more charged version of earlier themes. It contains just three elements: the ocean, a schooner in full sail, and a "thick of fog." As the schooner emerges from the fog, it is almost frightening to behold. It seems to owe its existence to two worlds, the seen and the unseen, the world of fact and the world of fancy. It is an apparition coming to life before our eyes like a magic polaroid.

deGarthe once gave an account of the evolution of this painting:

Pen and ink sketch.
Collection of Agnes deGarthe.

> Now there was one in particular I remember, and it bugged me and it bugged me. It bothered me so much. I have it at home and it's an upright. This will be the tenth summer I am putting it in the Marine Studio. It's in the same place and with the same frame. It's a schooner and it's called "Out of the Mist."

> All you see is the bow and a little bit of the sail as it moves out of the fog. Now that is a very odd painting. That painting, when I first did it about eleven years ago, I had finished it up and framed it. It was in my studio and it bugged me. There was something wrong, I don't know, the schooner coming toward you and all of a sudden one morning it hit me. I took it down and took

it out of the frame and put it on the easel. What happened then is what we call inspiration. It took me a couple of months to find the secret and all of a sudden one morning it came to me.

People of all walks of life come to the studio to see that painting. One time three girls came to see it and one turned away. I asked her why and she said she got goose pimples and chills from seeing it. Another man told me that if the "Mona Lisa" was hanging next to "Out of the Mist", and he could have either one, he would choose "Out of the Mist." Isn't that wonderful? It's too bad we haven't written down all the comments. It's a very eerie feeling.

In contrast to the towering schooner is the commonplace and unremarkable image of the dory, yet the dory makes its presence felt in innumerable paintings. For deGarthe, it is the vessel of the common man—the Model T and Volkswagen of the sea. More so than even the schooner, dories place men as close to the water as can be without actually swimming. There is a deGarthe painting that shows five men in a wooden row boat with an ocean wave in the foreground rising higher than the gunnel of the boat. The boat rests in a valley between waves and is almost completely hidden by the water, with just the men's heads and upper bodies showing. In the men's casual attitudes and ease of bearing, in their perfect balance within the rising and falling boat, we witness a fearlessness—they look like men unconcernedly playing cards on Charon's boat-ride into the underworld—born of trust and effortless coexistence with the elements.

There is a tremendous range of technique in these pictures. In some, the paint is applied so thinly that the texture of the canvas underneath forms a pattern over the whole; while in others, the paint is as thick as a Van Gogh; some are

Detail of the painting
Five Men in a Boat.
Collection of the Public Archives of Nova Scotia
Photo by George Georgakakos

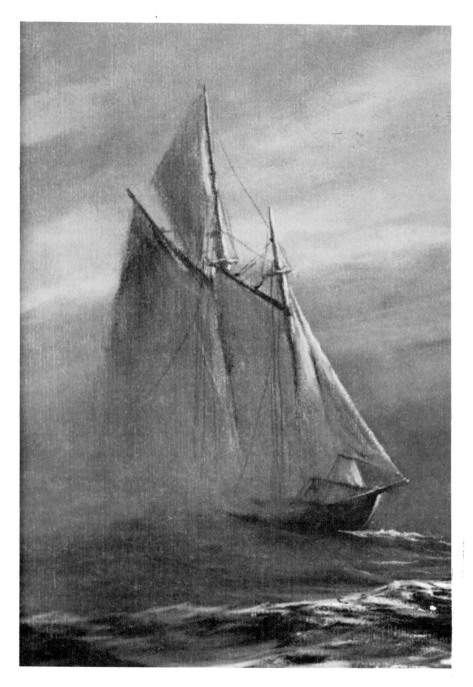

This detail from the painting Cape Island Boat and Schooner *approximates the composition and mood of* Out of the Mist. *It is possible to see the famous painting and deGarthe's favourite of all his works on display in the Studio Gallery in Peggy's Cove in the summer months.*

Photo by George Georgakakos

Study for the church mural, charcoal on paper, 1963.
Collection of Agnes deGarthe.

varnished heavily in the tradition of the old masters, making the surface glossy and slick; the brushwork is generally loose, but always controlled; even within a single canvas there is quite a range of brush strokes. The colours and compositions vary dramatically over the years; the later paintings often bring a foreground figure or element up close and cropped near a corner of the canvas to create a photographic effect, increasing the separation of foreground from background; the colours generally get lighter with the years, the early paintings are sometimes dark, with the reds brownish and the blues greenish and heavy; later paintings use white much more effectively, lending the overall picture a more spacious and airy atmosphere.

So concerned was deGarthe that people understand the meaning behind his paintings that he once wrote out an explanation of what he considered a major work and had it printed. This work is the ambitious mural done for the church in Peggy's Cove.

The mural consists of two companion paintings that are placed on the same wall behind the altar, but separated by a central stained glass window. One depicts a dory crowded with desperate men lost in a storm at sea; the other shows Christ walking on the water, surrounded by twelve seagulls, his arms outstretched to the men in the other work. As deGarthe explained it:

> All this is to symbolize the trials and tribulations mankind undergoes in his spiritual evolution to find his true self, to become Christ-like . . . all these are symbols to the questions and answers we seek.

His description is telling:

> The man in the bow of the boat, with strained face, not quite sure he has seen something; the man hanging on to the mast, with pointed hand, calling

to his mates, sees a lighthouse on the point; the
man at the oars, tired, semi-turned head,
doubtfully questioning; and the man at the tiller,
straining to see through the storm.

Each man represents a different emotional state or
reaction to this meteoric or spiritual crisis, but all are
essentially stages in the development of a single man—doubt,
fear, puzzlement, sudden hope, readiness, exhaustion, despair.
The crisis they undergo, the storm, is the same one described to
us by Dante:

> Midway upon the journey of life
> I find myself within a forest dark
> For the straightforward path has been lost.
> (*Inferno I,* 1-3)

The path, characterized by turmoil and self-doubt, leads
through an acceptance of our own limitations to a fuller
understanding of ourselves and our relation to the world. How
often major events in our lives—a declaration of love, learning
a new skill, changing jobs—is accompanied by confusion and
fear. But perhaps the biggest change any of us can imagine and
the greatest fear we have is of facing death. This seems to be the
true end of the journey of the men in deGarthe's boat.

The pointing hands may have been inspired by
Michelangelo's famous image of God creating Adam, but here
the artist has reversed the symbolism—the hands may never
touch, but if they do, the exchange will bring not life, but
death. And yet the mural is not morbid; it intimates a brave
challenge and a fantastic journey ahead, filled with
unimaginable wonders.

Unlike Jack Gray, the brilliant Nova Scotian marine
painter, whose pictures are infused with a gritty, biting light
and a concentrated, crisp, punchy, dangerous atmosphere—

The interior of St. John's Anglican Church in Peggy's Cove, Nova Scotia. deGarthe donated the two paintings mounted on the wall behind the altar in 1963. For security reasons, the church is closed to tourists.
Photo by the author

like a hard-boiled detective story set at sea; one expects to see a
Phillip Marlowe or Sam Spade emerge from under one of
those sou'westers—deGarthe does not pit man against nature.
With Gray, we feel his sympathy is with man and his machines,
that the sea is foreign to man's nature and an antagonist; with
deGarthe the struggle is pitted within man himself. Man is seen
as one with nature, so that a storm at sea symbolizes a storm
within the individual and similarly, a break in the clouds with
streaming shafts of light, illuminating a man paused in his
work, symbolizes a breakthrough, a reflection or insight into
self. This does not make deGarthe a better artist than Gray, or
vice versa, it just shows a different approach and a different
intention.

deGarthe very often depicts quiet moments, epiphanies of
inner reflection. He is concerned with reconciliation. His
paintings herald a self-contained universe. By single-mindedly
and obsessively painting Peggy's Cove, he tried to represent the
ideal fishing village, which stood as a microcosm for an ideal
world. He conveyed not only the physical features of that
world, but also the values that world embodied — simplicity,
strength, work and faith in yourself and your companions and
in the world around you — ultimately in an ordered cosmos.

Significantly this world is set in the past. It is as much
myth as history, reflecting the unconscious desires of all men
and all women. Just as it is good to have heroes, it is good to
have, as a culture, a collective memory of an heroic past.

A detail from the study for the church
mural, charcoal on paper, 1963.
Collection of Agnes deGarthe.

The Viking, *one of three related statues on display in the Marine Studio. deGarthe retained an almost boyish fascination for heroic figures to the end of his life.*

6 A monument in stone

*D*onald Crooks and his wife live on a steep hill overlooking the protected inlet and harbour of Peggy's Cove. Mrs. Crooks remembers a quiet, clear day when she was working in the kitchen. As she was finishing her chores, she noticed a sound she had never heard before. "Tap, tap, tap, that's all it was," she said. "I kept listening and it would start up again — tap, tap, tap. Now what in the world can that be! I thought. I opened the back door and there was Bill with a hammer and a chisel in his hand. He was working on the granite wall in his backyard about 50 yards away. After a minute he saw me watching him and waved. I asked him what he was doing and he said, 'I'm just playing!' That's what he said. 'I'm just playing.' "

deGarthe's "plaything" was the beginning of a ten-year project, a massive undertaking sculpting twenty-eight separate lifesize full length figures out of a steel-hard granite rock. Begun when he was 70 years old, he would only get it partially completed—he survived one heart attack midway through the work—and in the end, he asked that he be buried in it.

Sketch, charcoal on paper.
Collection of Agnes deGarthe.

He and Agnes had been going south, first to the West Indies, then to Florida, for many winters. It became his practice to take rough oil sketches with him and to work them up into finished paintings in the privacy and seclusion of his winter studio. But deGarthe was not by temperament an "indoor" painter. He started to travel about the coasts of Florida in search of fresh subject matter. On these travels he met many people, including a sculptor by the name of Leslie Posey. deGarthe visited him often and soon convinced the sculptor to take him on as a pupil.

It was only in Florida that deGarthe could relax enough to take the time to experiment with a new medium like sculpture. He set up shop in the open air on a sandy beach, shaping figures out of the local clay. It was a new adventure for him, yet not completely so. He said himself: "Do you know when I was a young fellow, 12 or 13, an artist came to our home and he thought I had the talent of a sculptor. This is the ironic part, that here in my old age I am going into sculpture. I am finally fulfilling that prophecy." Agnes told me that even in the early days in Peggy's Cove he would take a chisel and a hammer with him on his long evening walks. Once alone, he would carve a face on a huge boulder in a remote area of the cove and leave it to defy the elements; its only audience the passing gulls. As with painting, it seems that deGarthe had tried many experiments on his own before seeking the advice and instruction of others.

His primary source of instruction came over three winters, starting in 1976. On a holiday in Italy the previous year, deGarthe had made some inquiries. He was directed to the town of Pietrasanta, near Pisa, where he was shown an assortment of marble quarries. He would write: "You can see the white holes in the mountains shining in the sunlight—it is beautiful!"

The name of the town means "Holy Stone", which indicates the esteem sculpture is held in Pietrasanta. Whole

streets are composed of nothing but studios and shops selling chisels, drills and related tools. Visitors come from all over the world to advance their skills. On this first trip deGarthe strolled through the central plaza past the Bar Michelangelo and innumerable churches to enter a busy workshop. Everywhere he looked he saw fragmented copies of Renaissance masterworks—a giant eye, nose, ear, a Pieta or a madonna and angel, caked in the white dust that permeated each room and made men look like ghosts. The marble workers themselves were jovial and passionately absorbed in their work. A saying told to apprentices who accidentally cut themselves—it's not hard working with sharp chisels—is: "When the blood flows out, the mastery enters."

deGarthe was enthralled. In his mind he calculated the time and the expense of a thorough apprenticeship. The labour involved he didn't give a thought to, that was the easy part. He approached the owner of the studio and made the necessary arrangements to return the next year.

A cartoon shows him stepping off a train and hailing a cab in the rain. An old man alone in a foreign country. He doesn't speak Italian, yet he is buoyantly happy. "Strangely, it feels as if I never left here," he wrote his wife. "Time hasn't changed anything. Sig. Paglia and Sign. Mila happy to see me, Richardo still serving me at the table, handsome as ever, no change in the menu, the wine tastes the same . . . everyone happy to see me at the Hotel, again it was like coming home."

On another trip deGarthe was so anxious to get to work that when he arrived on a local holiday with all the shops and businesses closed, he could not contain his disappointment. He had hoped to get down to the quarry to pick out a stone; now it meant he would have to wait an extra day. He was increasingly conscious of time and of wasted time. All his letters from this trip provide the time as well as the date on which they were written. And if he happened to be interrupted in the midst of a letter, the time he resumed writing would likewise be noted.

From a letter to Agnes, January, 1977.
Collection of Agnes deGarthe.

The statue in this cartoon is of Peggy, reproduced opposite.
Collection of Agnes deGarthe.

Working with hammer and chisel was heavy going for one not used to it. deGarthe was in his sixtieth year when he wrote in one letter: "As you can see by the cartoon, the chips are flying, the arms and shoulders are aching, but feeling good, happy in my work." Later he wrote: "My shoulders and arms are not too bad, still aching, later my hands are going to take a beating . . ." and "Just got back from the shop and my arms and hands are tired. For two days on the compressor drill, but more than pleased of my progress."

He experienced a complete range of moods, common to anyone learning a complicated new skill. One day he would be tired and sulking, another he would be charged with optimism. He was a determined pupil and not easily discouraged. He wrote: "I think I got myself in a mess today and need some help tomorrow, but getting bolder in my approach, even if it does not turn out exactly as the model, I'll do it and tomorrow I'm really 'going to town.' "

Many of the statues deGarthe produced during these winters were of stylized female nudes, Art Deco-like figures with arms outstretched and twisting bodies. The work is competent, skillfully designed and executed, but lacks the emotion of cruder, more primitive pieces that he was leaning increasingly toward. The more skill and confidence he acquired, the more he turned away from the academic models surrounding him in Pietrasanta. He carved a bas relief of a nude woman; in her hand at rest against her hip is a basket of fish. Her free hand is raised in a gesture or sign to us, the hand is open, palm out and free of any object. Is it a signal of greeting—her face is turned away in profile—or is it a gesture of warning, bidding us to stop? Is she offering a blessing over the food in her arms, is she the source of the food, an earth mother or fertility goddess? The sexuality of the figure is quite explicit, yet she emerges out of the rock not quite human. She is extra human, divine. Only then does it become clear who she is meant to represent: the Peggy of Peggy's Cove.

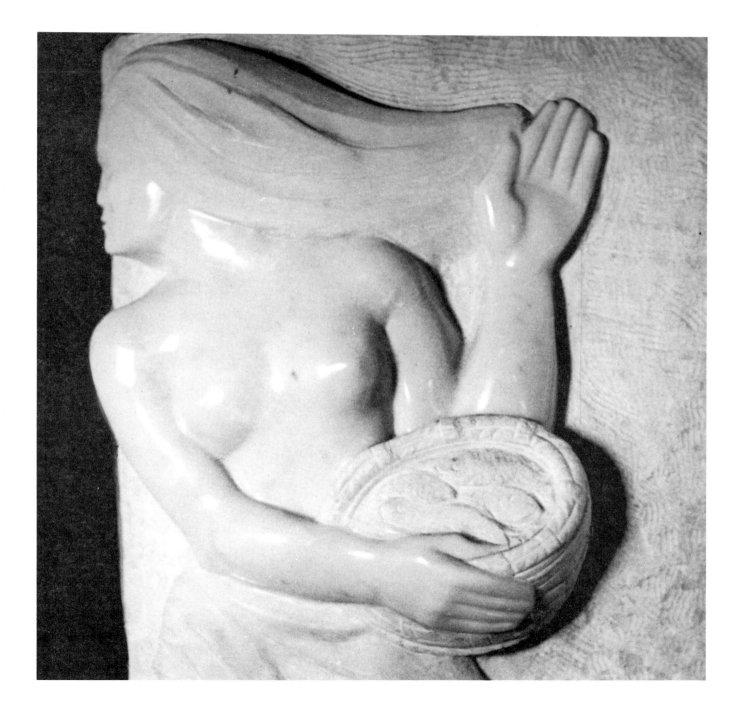

The Christ statue, Rio de Janeiro, Brazil.

deGarthe had returned via classical nude figures to his predominant concern, the fishermen and women of Peggy's Cove. Carving figures in bas relief (sculptures that are only partly raised or separated from a flat background) seems a direct preparation for bringing figures out of the granite wall in his backyard. He did one final work in Italy, a study of a fisherman's family grouped under the outstretched protective arms of an angel. This would be his exam, thesis and graduation diploma. On its completion he would say good-bye to Italy for good and concentrate on his own themes.

When deGarthe left Finland at the age of 19, his intention had been to travel around the world. An aunt in Brazil had extended an open invitation and he had planned to visit her. However it was not until some 50 years later that this visit became a reality. The aunt lived in Rio de Janeiro, "the River of January," famous for its spectacular 100-foot high statue of Christ, towering 2200 feet above Rio's harbour. The statue represents Christ with his arms outstretched at his sides; it is the crucifix image but without the supporting cross.

This Rio Christ impressed deGarthe. Just forming in his mind at this time was the idea for an ambitious community monument that would serve as a memorial to fishermen. For direct precedents, he was aware of *The Man at the Wheel* statue by Leonard Craske in Gloucester, Massachusetts. Even Kaskö, Finland had erected a modest cairn in memory of men lost at sea. deGarthe assimilated these different concepts, the religious icon and tribute to a dangerous profession, adding a moral aspect all his own; namely, that there should be a spiritual reward for a life of good work.

His monument when completed would constitute a grand parade of working men, led by the charismatic Peggy, being blessed and received by an angel of mercy. The long, curving line of rock suggests the hull of a boat. At one extreme end of the work, a boat is being hauled into the frieze of men. A rope from this boat dips and waves through the entire wall, linking

each figure in a rythmical, linear movement—a movement that implies, as it makes its way to the all embracing angel, a voyage from earth to heaven. Beside the angel is a gull, a symbol for the soul, and beside the gull is a man at a wheel, steering its course into eternity.

deGarthe wanted his monument to be dedicated to the men of the sea. He stressed that it was universally applicable to all fishermen. When asked why he had singled out fishermen, he answered: "Let me put it this way. Why not give a monument to these people who devote their whole lives for the benefit of others and who are always exposed to danger?" His other motive was a personal one. "I've seen them come with the fish from the sea and unload their boats day after day," he said. "I've been to sea with them and also *I feel close to them.*"

The fisherman's family from the Fishermen's Monument.

*G*etting started was no problem for deGarthe. At first, he told no one the scope of his intentions. He may not have known himself. He took his time searching for a suitable spot to start carving. Anyone who has been to Peggy's Cove knows that there is no shortage of rock. One senses deGarthe was always able to match his artistic ideas, however farfetched, to a practical avenue or opportunity. Living among so much stone, he was determined to become a sculptor to make use of it. Also he felt a true affinity with the place and with the rock itself. He said once: "I have an enduring affection for the granite country, why I don't quite know. Perhaps because I have frequently drawn and painted it. Perhaps because it reminds me of my Calvinist ancestors, sour, grim but strong, uncompromising, and in spite of itself beautiful. I believe if you too were to sketch it, you would like me come to love it." He often told his neighbors that he wanted to be buried in the rock of Peggy's Cove—a wish that was fulfilled. When talking to reporters of his experiences in Italy and of his apprenticeship in marble, he would always bring into the

discussion mention of the granite in Peggy's Cove. It was the material he felt most appropriate to the men and women who make their living from the sea.

deGarthe had thought originally of using the rock wall that his house looms above, facing his studio and the wharves and harbour. Agnes came up with a more practical solution. Why not try the wall in the backyard? There was a wide expanse of lawn in front, it was easy to work at as well as to view and the wall faced south so it would be in the sun all day. deGarthe agreed.

He started working on the group of Peggy surrounded by fishermen. He carved the faces in the likeness of his friends and neighbors. He never asked anyone to pose, he worked from memory. As in his cartoons, he exaggerated the prominent features and eliminated unnecessary detail. After a few initial trials, as he became convinced of the feasibility of his project and began adding more figures in his mind, he transferred his plans to paper. Out of many sketches emerged a master plan. This paper, which assistants spoke of with a kind of awe, was kept in a large roll like a scroll or architect's blueprint. How often at difficult moments it would be unrolled and scrutinized, then compared to the work in progress.

deGarthe valued ideas. He himself was full of them and he valued the spontaneity and high spirits out of which an idea can grow. His work was attracting a lot of attention. The sculptor talked to many people while he worked. He often gave an account of what figures would be carved where. In the spots where he was still uncertain, he extemporized. Sometimes he made extraordinary claims. "I think I'll put a schooner—the *Bluenose*—in full sail—there—on that ledge above the men. And over there I'll put a giant whale and a man with a wooden leg. There'll be a harpoon in his hand, raised up high like he's about to strike . . ." "Moby Dick and Captain Ahab!" "Yes . . ." he smiles and looks closely at those around him. Do they take him seriously? Should they?

Collaborators told me that he tried ideas out on them and weighed their reactions. It was all done in a good humoured and joking fashion, which made it hard to tell just how serious he was at any given moment.

It was at about this time that a reporter—and he was approached by an increasing number of them—suggested to him the possibility of his retiring. deGarthe was adamant in his response:

> I'll do no such thing. I don't even want to think of it! I feel like I'm 38—I'm strong, eat three meals a day and I love to work and I use the word 'love'. I get up at 6:30 a.m. in our home at Peggy's Cove (it used to be 6:00) and there's no stopping from morning 'til night. Both my wife and I love to dig in the garden and I really enjoy splitting wood and carrying it into the house. The neighbors ask if they can do it for me and I say "No!" This is how I feel.

He was extremely spry and active for a man of his age—or any age—and he prided himself on it. Yet as time went on, he would accept some help on the carving of the monument.

A sketch of the Fishermen's Monument, showing clearly the three sections, which could be labeled by theme: Grace — the family under the protection of an angel; Bounty — the legendary Peggy with a basket of plenty and villagers with a huge fish; Work — men fishing and hauling a boat. The three sections follow natural divisions in the rock.
Collection of Doris Saunders-Hynes

Pages 108-9: The Monument is "bracketed" by a dory at one end and a man at a wheel at the other. The work is unified throughout by a rhythmical line of ropes and nets.

Page 110: A fisherman's family and protective angel. This is one of the few families depicted in all of deGarthe's art.

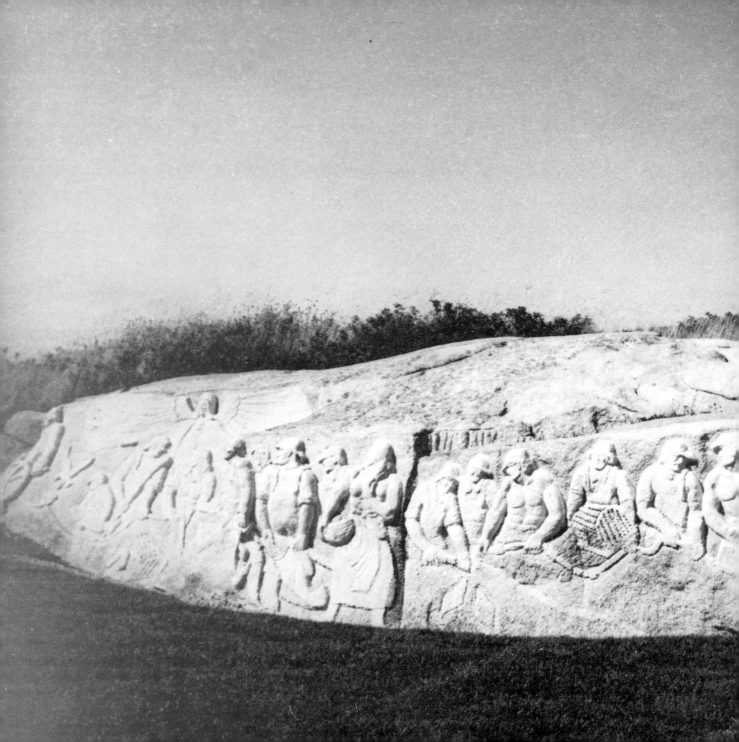

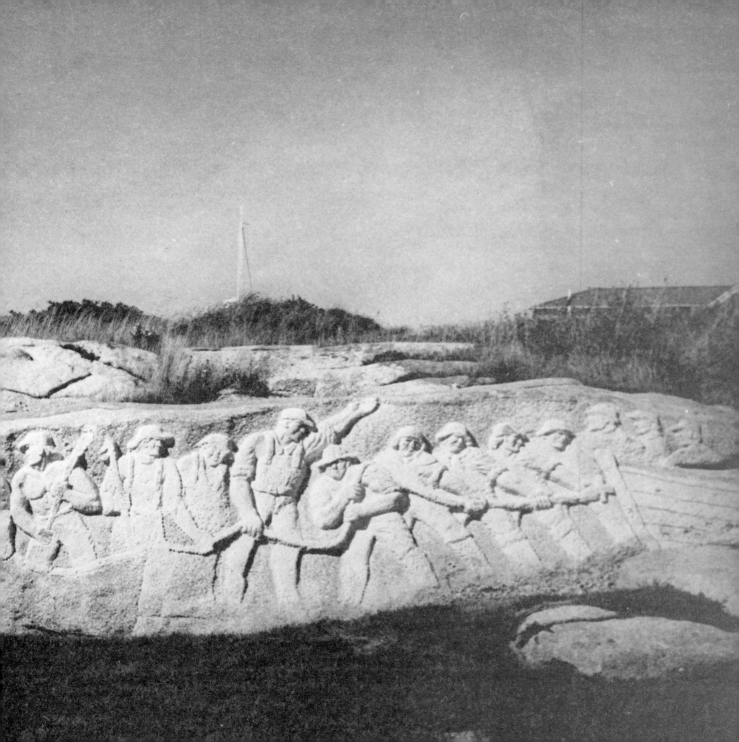

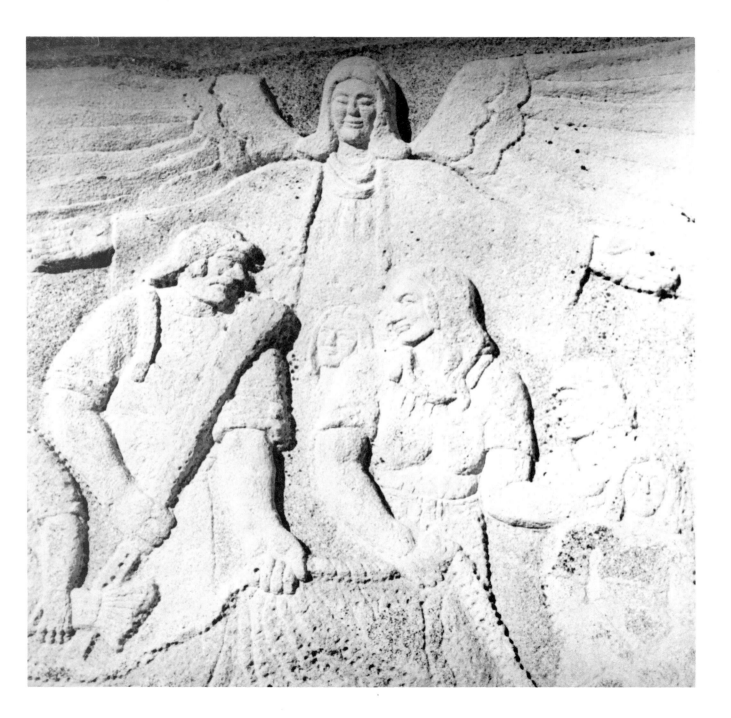

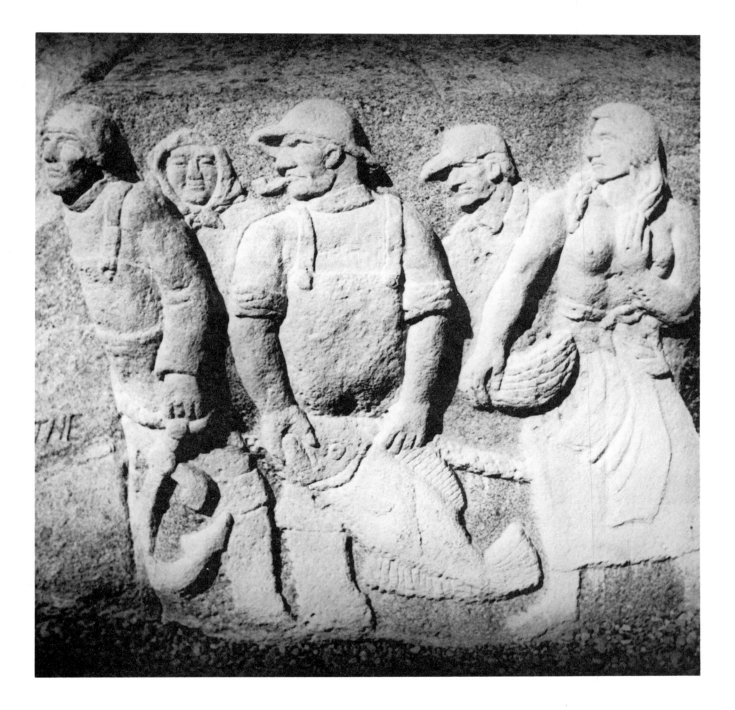

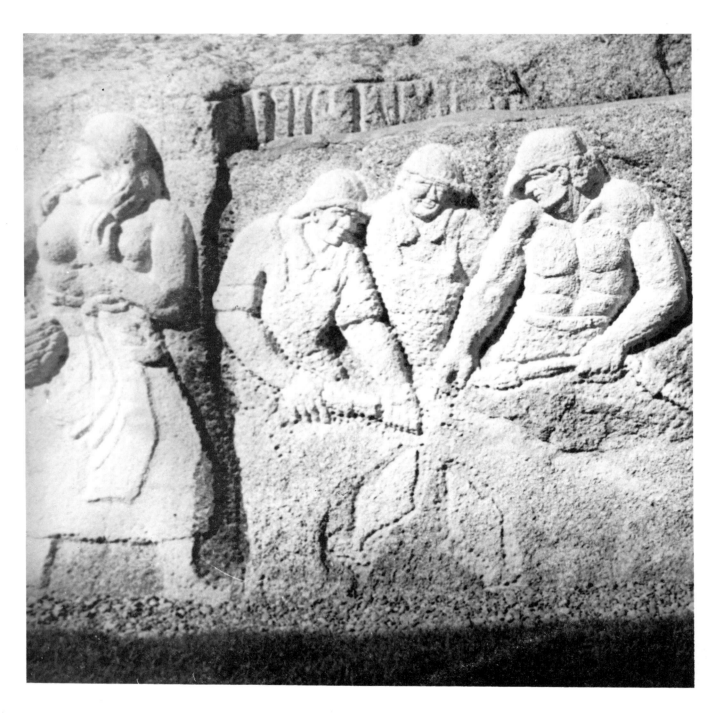

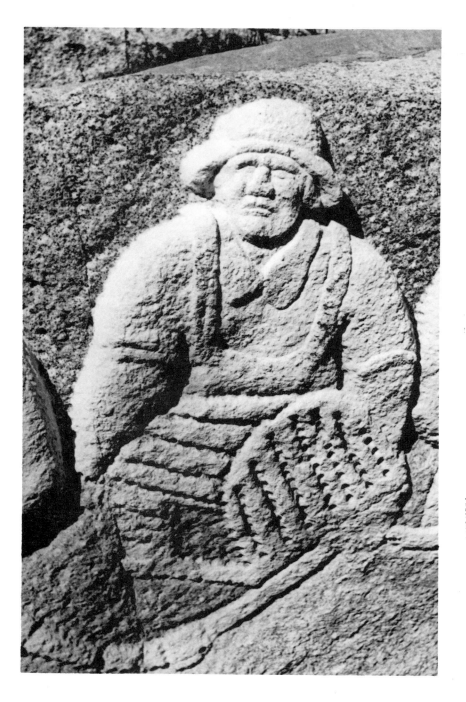

Left: Man with a lobster pot. An arresting figure that gazes directly out at the viewer.

Far left: deGarthe's design worked around natural clefts in the rock, as here divides Peggy from the group of three fishermen working with a net. The presence of fish in the net suggests the men are working from a boat offshore.

Page 111: The angled and protruding man with the anchor — the first figure deGarthe worked on — brings to mind the figurehead of a boat. A boat motif is prominent throughout the sculpted rock. The bare-breasted woman with the basket represents Peggy of Peggy's Cove. She stands in front of the rope or net that winds through the work — the only figure in the monument to do so.

113

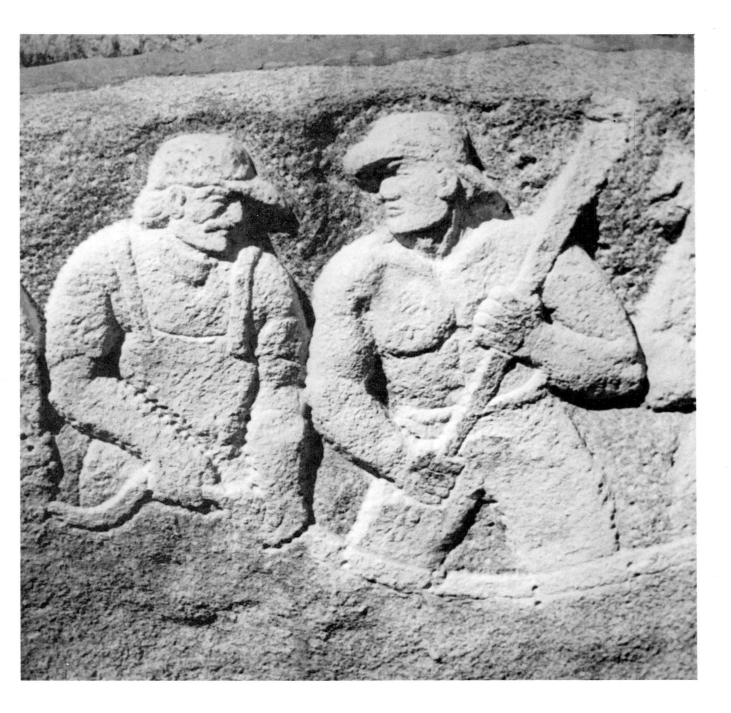

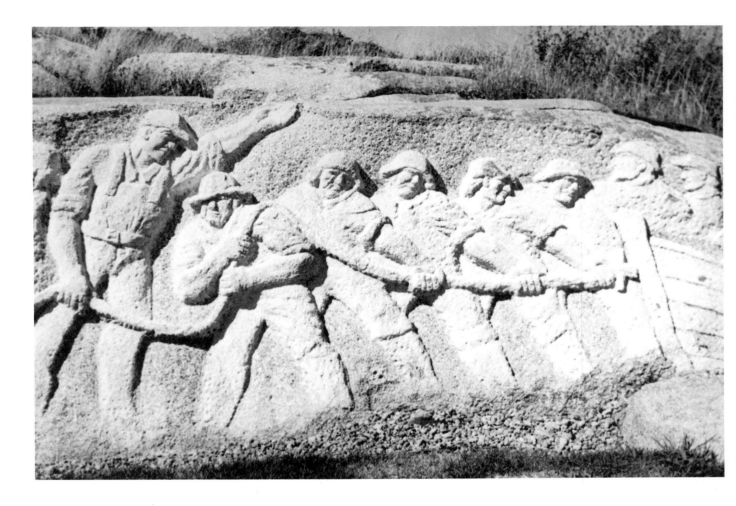

Left: "The improvement in his skill as
a sculptor," wrote René Barrette,
"is evident by comparing the
early figures, which are rigid and
erect, to the later figures, which are
loose and action-oriented." One
can see the impulse toward action in
these muscular forms.

Above: These men hauling a boat
are the least worked on figures on the
monument. Nonetheless deGarthe
has achieved a convincing
sense of motion by repeating
the form of the pulling man.

All photos of the monument are by the author.

There were two key collaborators: René Barrette and Donald Crooks. René, a retired serviceman, had taken one of deGarthe's painting workshops earlier that summer. René kept up his contact and they had become friends. Donald Crooks was a retired businessman. Living next door to deGarthe, he often dropped by to chat and to see the progress on the work. René was the first to get involved. After a year or two he moved out of the province and Donald took over from him. With both men it was part labour of love and part tribute to a man they admired and respected. There was no payment except for such things as free lunches, a gift of a painting, a trip to the States. As René would write me: "There is not enough money in the world to pay someone to carve granite day after day." I asked him how hard the work was and this was his reply:

> My diary is full of statements regarding how tired I was after a day's work on the rock. The manipulation of the drills and the compressor would shake my body so much I would lose my appetite. Lunch usually consisted of a coke and a muffin and I would not eat until 9 or 10 in the evening when the tension caused by the vibration would cease. (However this tiredness always felt good and caused a good sleep.)

> If I drove back to Hampton or Halifax after a day's effort, I would often stop the car and walk around to prevent myself from falling asleep at the wheel.

As work continued, old friends from the *Herald* dropped in to check on deGarthe's progress. deGarthe invited one of these reporters, Doris Saunders-Hynes, a strong and vigorous woman, to try her hand at the mallet and chisel for the benefit of a photographer. She said: "I swung the hammer down as hard as I could—what happened? The chisel just bounced off the rock. It didn't even make a dent." Donald Crooks put it this

way: "It's hard—like iron—rock hard . . . it didn't happen overnight."

The first serious setback to work on the monument was a heart attack deGarthe suffered in 1979. He spent four weeks in a hospital in Halifax, but at the end of that time he was desperately anxious to return to his sculpture. He was to boast later to a newspaperman that work on his monument was the best cure for a heart attack and that doctors should send recovering patients to him, he'd fix them up, banging on the rock.

All his life one of deGarthe's favourite recreations had been to go on sketching trips with his friends. A pet spot in recent years was Bush Island, near Bridgewater. His companions were two former students, René Barrette and François Delisle. Though it was fun, they also took it seriously, as René noted:

Reporter Doris Saunders-Hynes is invited to try her hand with a chisel. deGarthe, looking very thin, looks on.
Photo by David Hynes.

> The preparations for a day of painting with Bill were like getting ready for a safari. Making sure we had lots of food and refreshment necessitated lots of organization . . . once on site, Bill would establish himself and usually start painting a small canvas board (6x9) and eventually work up to 16x20 by the end of the day. He would generally complete the paintings on site so he would have several sketches in various stages by the end of the day. He usually had a nap after lunch (which was more like a feast). He enjoyed good food . . .

> At the end of the day he would return to the motel, review the day's activities and eventually turn to discussing the Monument. He was always planning ahead attempting to visualize the way the sculpture would look after some additional work.

More and more, the monument was on his mind. There came a point when he turned down offers by his friends to go on even a short excursion. The number of days left to him were

numbered, he must have felt, and he wanted them all spent working on what he knew would be his last great work. A neighbor told me: "He used to say, 'Please Lord, let me live to finish the Monument,' but he said he cheated because he kept adding on to it, by adding new figures to the rock."

One thing he did do was to cut back on the time he spent in Florida, leaving later each year and returning earlier in the spring. François Delisle remembers driving down to Peggy's Cove late in the fall. He got out of his car near the restaurant. It was bitterly cold, the sort of day when people run out of their cars to the nearest indoor spot. That's what he was about to do when he heard from way off in the distance "ping, ping, ping," a hollow sound echoing through the village. Bill must be working, he thought. He stood and listened for awhile to the slow and methodical clanging of the hammer. From so far off, it sounded eerie, like the distorted heartbeat of a man obsessed. Then the cold became unbearable and he went inside.

Neighbors told me he would work long into the evenings. "He used to do too much at a time, I can tell you that!" Mrs. Crooks told me. deGarthe had been feeling weaker of late. He went to see a doctor and was told he had cancer. According to René Barrette:

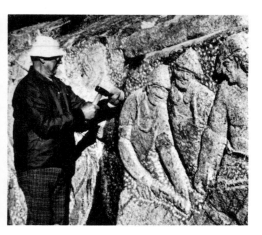

The sculptor is bundled against the cold.
Photo by Nova Scotia Government Information Services.

> I believe very few people were aware of how sick Bill deGarthe was in the 1980s. He had too much courage and spirit to lie down and mope. Surprisingly because of that spirit and courage very few people were aware of the situation. Many days he was too weak to do anything but fine chisel work for short periods of time. Both Don Crooks and I contributed to the scam by calling for several "union/labour contract coffee breaks" and suggesting it was his turn to brief the tourists on the monument. All of it to give him a rest. But he was aware of what we were doing . . .

Both René and Don felt for the old man's condition, but

realized that he was too determined to stop halfway. So they joined him and helped as best they could. Their main task was to cut stone away to create negative space, allowing the carved figures to project outward from the rock. deGarthe used paint to sketch the outline of each character. Then after some of the background had been removed by drills, the fine chiselling of faces and the details of the clothes, hands and props would begin. If the sculpture is now incomplete, it is in this regard. The figures don't project outward from the background stone as much as their creator would have liked. Also the massiveness of the bodies of many of the figures, the fact that their shoulders, arms and hips are unnaturally stout, is due to the fact that they were never finished.[1]

deGarthe died in a hospital in Toronto on February 13, 1983. According to his wishes, his body was cremated and his ashes were placed in a vault designed by himself inside his last great work of art—the monument in Peggy's Cove. It marked the ultimate identification of the sculptor with his work.

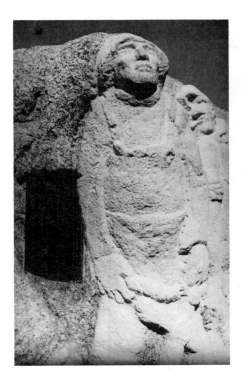

The memorial plaque which seals the vault containing deGarthe's ashes.
Photo by the author.

*L*ocated inches beneath the outstretched fingers of his granite angel and beside a symbolic family, the artist who left no children rests in peace. He who had spent so much of his life watching and recording the daily lives of fishermen would now be watched over in turn by this stoical line of stony men. He once told a close friend: "I am here physically and I am here spiritually." Of his commitment to Peggy's Cove, one could ask no more.

There were a number of tributes printed in all the local papers. An obituary appeared on the front page of a newspaper in Kaskö, Finland, the city he had left fifty years ago. These words appeared in a tribute by Basil Deakin:

> It was cool and windy, and as the final words of
> the rector's committal were spoken, and as the
> masons took leave of their brother, the rain began

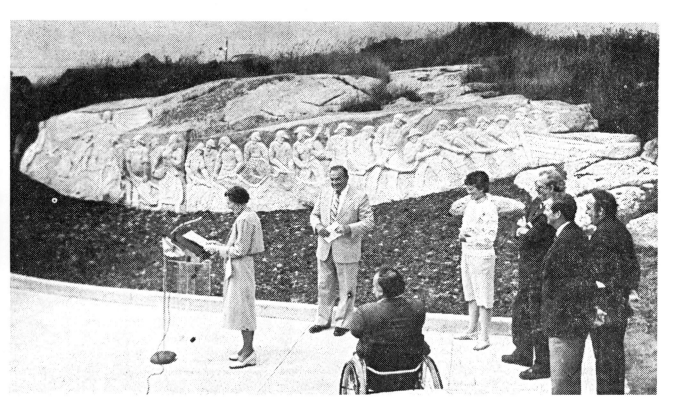

"I hope everyone who comes here will enjoy this as much as he did putting it here," said Agnes deGarthe at the ceremony officially donating the monument to the government of Nova Scotia in 1985.
Photo by Paul Schneidereit.

to fall. Between 100 and 150 mourners, whose numbers included neighbors, friends and admirers, Halifax Mayor Ron Wallace and a few fellow artists, bowed their heads and remembered the distinguished, inventive and forceful man who had made such a mark, not only on Peggy's Cove where he created so many of his paintings, but on the field of popular art.

The 100 or so who had earlier crowded into the small attractive Saint John's Anglican Church, where deGarthe's ashes were placed before the altar in a velvet cloth-covered container on which Mrs. Agnes deGarthe placed a single red rose, may have felt the painter's presence as they looked at the two large paintings hanging on either side of the altar. They depicted on one side, a dory filled with fishermen lost in the fog in rough seas, being guided safely home by the figure of Christ, shown in the other painting standing on the shore guiding them to a certain haven.

deGarthe's obituary appeared on the front page of the *Halifax Herald*. Two days later he was the subject of an editorial that read in part:

> William deGarthe was a great artist. He was a loyal Nova Scotian. He has richly blessed the lives of all of us as his work will continue to do through the many generations which must pass before the elements succeed in erasing his masterpiece from the rocks of Peggy's Cove.

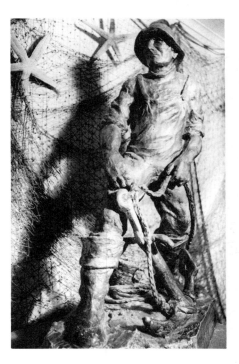

Man with an Anchor, *a three-foot high statue on display in the Marine Studio.*
Collection of Agnes deGarthe.

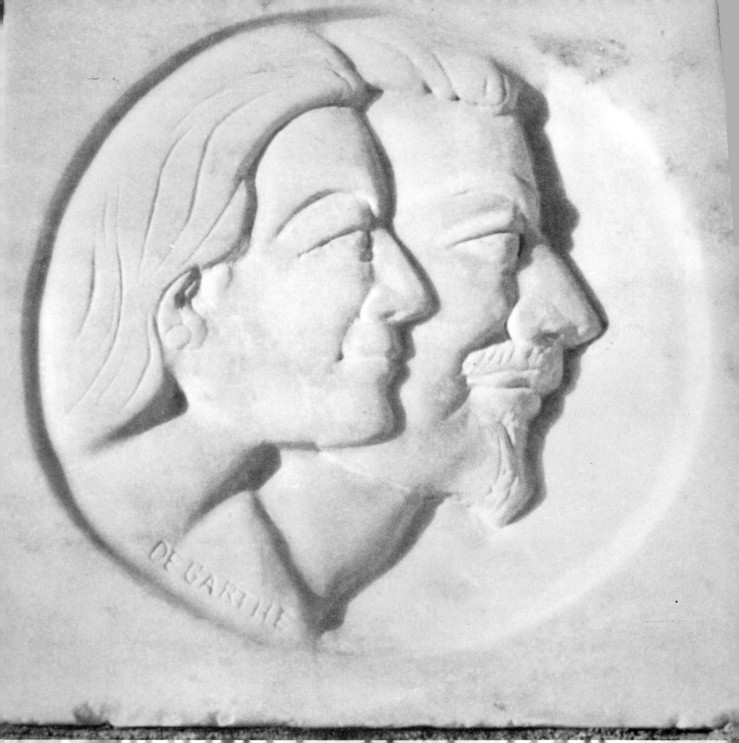

7 Bigger than life

A noted psychologist once listed four distinctive character traits held in common by men who had achieved a great deal in their lives. First of these traits was the ability to work hard and to put in long hours. Second was a sense of the pressingness and preciousness of time; the feeling that if they are not doing something each minute and each second, then they were squandering an opportunity and letting themselves down. A third trait was a strong sense of themselves, whether we call it self-confidence or simply egotism. A famous writer once spoke of a "necessary egotism" in the life of anyone who wants "to express himself and reveal what is best in him—not out of vanity, but because of the most natural necessity to become aware of, to embody and to fulfill his Ego in real life."[1]

A final trait of these achievers was having big ideas. It's as if these men were visionaries and could see possibilities where others could not. To such men the big idea fires and pumps them up, giving them a supermotivation and making them almost bigger than life. Michelangelo painting the ceiling of the Sistine Chapel was such a man, and so in his own way, was William deGarthe, who tackled a 100-foot-long granite wall in his 70th year.

A life-size cameo self-portrait of the artist with his wife sculpted in marble and inset into the granite wall of the Fishermen's Monument.

Conducting the interviews for this book, I was continually meeting people who had spoken with deGarthe and who remember that he enjoyed talking with them, but there came a point where he felt he couldn't afford to give them any more time. "This sculpture's not going to get done by sitting here yapping," he told Keith Cleveland shortly before he died. Keith had gone fishing with him as a boy. Neighbors told me that deGarthe ran his life on such a strict schedule that they were reluctant to intrude on him, for fear of throwing him off. In his earliest letters home from Montreal, he was giving an account of his day hour by hour. deGarthe always referred to the Fishermen's Monument as a ten-year project. He liked to work on a big scale, but even on the most ambitious of these, there was a limit and he was keeping track of time.

But deGarthe was acutely aware of another kind of time, one we might call eternity or posterity. Just as he was concerned with how the fishermen of old and the days of the fishing schooners would be remembered, so he was concerned with how he himself would be remembered. He once came in conflict with the rector of a church because he wanted to donate a stained-glass window in memory of himself. The minister thought this was an inappropriate action for a man who was still alive. It may be that deGarthe, who had a strong belief in God but was not a church-going man, thought of his gift as a stand-in for himself, a kind of representation in church by proxy.

In many ways the church, man's strongest symbol of longing for eternity, could not satisfy deGarthe's unorthodox personality. On the one hand, he was too much an individualist to take part in group worship; on the other hand, he had developed his own symbols, and though they could be made to serve Christian ideology, they were generally broader and more ambiguous in their intentions than those of the church. Both sides realized their differences and maintained a healthy respect for the other. But this persistent need to leave his mark

on history remained with deGarthe and he began looking for other avenues or "roads to eternity."

The aging painter approached the owner of a gallery and a respected appraiser of art. He made an extraordinary confession. He regretted how quickly he'd done many of his paintings and was afraid that his better work was not readily available to the public. He wanted to right the balance through a gesture, the magnanimity of which would be apparent to all. He wanted to come clean, to—in his own words—"give something back."

All his life he had sold his paintings for money in private exchanges; now he wanted to give paintings away—his very best paintings—to be owned by the public at large. The gift he proposed, consisting of 25 of his better paintings, dating from the earliest period in his career and extending up to the present, was estimated to have a value of $140,000.[2] He wanted the gift to go to the Art Gallery of Nova Scotia. Incredibly, it was rejected.

It may be that the orthodoxy of the art establishment is not so very different from that of the church. They too could not accommodate this highly successful but self-made man. (The art gallery does own two deGarthe paintings and may have felt that this sufficiently represented the Nova Scotian artist). So it was finally to the Archives that deGarthe was to turn. This institution only too gladly accepted the work. The Premier and the Lieutenant Governor were both involved in the ceremony of the handing over of the paintings. But hereafter deGarthe would speak of the historical importance of his work and play down the fact that they are, after all, paintings and works of art.

Paintings as *objets d'art* or expensive merchandise seem to have lost much of their interest for this man—so often accused of commercialism—in his later years. From the late 60s on, deGarthe concentrated on his sculptures, many pieces of which were not for sale. His most important work of

sculpture, the massive Fishermen's Monument, was never intended to be sold. deGarthe donated the work to the government of Nova Scotia — which means that he spent the last five years of his life, excepting winters, working for no financial renumeration. This was not a "puttering around" sort of a hobby, but long, hard, sweaty work of an intense physical nature. For good or for bad, the man had a mission.

How big were the ideas of deGarthe and his friends? One illustration is the story of the obscure island of Outer Bald, off Yarmouth, which a rich American executive and sportsman bought for $250 and turned into the Principality of Outer Baldonia. He declared it an independent state as part of a practical joke that was taken to extraordinary lengths. Currency was printed, a flag was designed and a constitution was drawn up which forbid women, taxes and double talk. Forty-eight prominent Nova Scotians were recruited to become "princes"; among them were Ron Wallace, who became Ambassador to Canada, and William deGarthe, who was named the first resident artist, though, of course, he didn't live there. The new "nation" received inquiries from the National Geographic Society and was the subject of an abusive newsstory in the Soviet Union (the Soviets feared for the exploitation of the local fishermen). Though it all eventually blew over, the episode parodied in a way that few could ignore the seriousness of nationhood and brought into question what exactly constituted a nation. The perpetrators of the hoax enjoyed Outer Baldonia, located within sight of the International Tuna Tournament, as a sportsman's paradise and used it to foster an outlandish free-for-all of humour and verbal irreverence. In short, it allowed a group of men to be more free than they were in their day-to-day lives. Of course, such freedom was itself a joke, but wouldn't we all like to own an island, to start our own colony and to make up a whole new set of rules about how everything will run? It is the dream of Utopia, of regaining the paradise that once was lost.

A Norwegian told me the story of how he came to Canada. Though trained to be a horticulturist, he allowed his brother to talk him into signing on with a whaling ship. As he had never been on a boat before, he became ill and was generally miserable. But while he was at sea, Hitler's troops invaded Norway and took the country by storm. The horticulturist could not return to Norway; all normal traffic had been closed. He ended up in Halifax, where he was contacted by the government-in-exile. They persuaded him to join the Allied navy. By the time the war ended, he decided to stay in Canada.

This is one of the countless stories that could be told all on the same theme. It is the story of transition, of progress, and of loss. In the movie *Citizen Kane*, there is a line: "He was a man who owned a great deal and lost it all." The same might be said of any man's past or of any nation's. The word nostalgia derives from the Greek root "nostos"—a return home. What is home for most of us? It is a memory more than a place, it is the way things used to be and can never be again.

There is sadness in much of deGarthe's work. How many pictures did he paint of men working on the Grand Banks in ships far from home? How often does he contrast the ghost-like schooner, vision of the past, with the modern fisherman in a motorized craft—often heading toward each other on a collision course? A famous painting by Alex Colville depicts a horse galloping on a railway track toward an oncoming train. It is the same theme. In the Colville painting, the setting is dusk; the image is something out of a nightmare or a very disturbing dream. Or was it always there at some primal level of consciousness? There is the story of Odyssius returning home after the bitter and exhausting ten-year-long Trojan war and in his heart of hearts not wanting to come home, unable to come home. Rip Van Winkle went to sleep for twenty years and when he woke up the world had changed. deGarthe left an island city with its harbour full of ships in search of new experiences in the New World and new sensations to

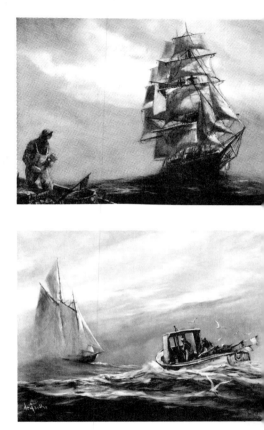

Variations on the ghost ship theme; both paintings bring past and present together in a dramatic confrontation.
Photos by George Georgakakos

127

immortalize in paint. And what did he find? That he had not left the ships, the glory days of old, so much as they had left him and the world at large. And that only then did he begin to miss them—and indeed to miss them as part of his past and memory and being. He realized the feeling was universal. All people felt it.

*J*ust days before this manuscript went to press, I called Agnes deGarthe to ask her about a sculpture in red marble that sits on the porch of her house and acts as a sentinel before the door to her private gallery. The question had been floating in the back of my mind for some time, but I had never gotten around to asking until now: "What is the subject of that red sculpture?"

"Why, that's Diana, goddess of the hunt," she said, "and on the back of the stone are carved a herd of deer." I remembered a heroine vigorously aiming a bow and arrow.

"What was his interest in Diana?" I asked. I did not know then she was a solitary creature who loved animals but hunted them; sometimes called chaste Diana, also wild Diana, she was a guardian of primitive, untamed frontiers and feelings...[3]

"Oh, he was interested in all the old stories, the great myths," said Agnes.

Perhaps he was attracted to the great myths because he was himself a mythmaker. And like many artists, with time his mythology—his art—and his life drew inseparably together. In the course of his life he would try on many roles: the carefree bon vivant, musician and joker, outdoorsman and city sophisticate, goodwill ambassador, husband, artist and finally—inevitably—the grand old man.

He was busy to the end, creating effigies that he guarded with stone angels and that in turn would guard over him. His art dealt with the past, but its purpose was that it be seen in the

present—to affirm life over death, to create a meaningful link between generations and establish a continuity with the best of what has gone before. The French say of this: "Je me souviens"—I remember. One need only look at deGarthe's monument and tomb to know that toward this end he gave it his all.

At Balantine's Cove.
Photo by François Delisle.

Photo by François Delisle.

Notes

Chapter 1

1. *Scandinavia* (New York: Fodor, 1966), p. 174.

Chapter 2

1. All deGarthe letters quoted in this chapter are from Swedish originals and were translated by David Brekke.

Chapter 3

1. Some of my correspondents found it hard to imagine deGarthe as a fighting man. Chambers used to kid his friend that he would have to be arrested as a war spy since Russia, the enemy of Finland, had joined forces with the Allies. But another friend said that deGarthe would fight "for anything that he believed in or thought was right." deGarthe's loyalties were as strained as they could be. He had to decide whether or not to fight, then to decide which *side* to fight on: with Canada and the Allies or with Finland and the Axis. Under the circumstances, he perhaps wisely did nothing.
2. From a letter to Agnes, dated January 12, 1979. deGarthe was studying in Pietrasanta at a sculpture studio. In the letter he refers to a large marble bas relief he had just started and one that would serve as a study for a major section of the Fishermen's Monument in Peggy's Cove.
3. Winslow Homer was a name often brought to the attention of deGarthe's students. Another marine painter he admired was Frederic Waugh of Boston.

Chapter 4

1. Helen Creighton, noted folklorist of Nova Scotia, assured me there was a belief in the legend that predated deGarthe. Mrs. deGarthe told me her husband heard the legend from Louis Crooks. In *Place Names of the Province of Nova Scotia,* compiled by Thomas J. Brown and published in 1922—deGarthe first visited Peggy's Cove in 1931—there is this one sentence under the heading of Peggy's Cove: "Locally said to be named after a woman named Peggy, an early settler." Obviously there was some basis for the the legend as deGarthe printed it. However, knowledge of this had largely disappeared from the cove by the 1950s and many residents had never heard of it. The Public Archives of Nova Scotia printed a version of the legend that is markedly different in many details, leaving out the shipwreck and the marriage of Peggy. It is as likely that deGarthe embellished an existing story as it is indisputable that his pamphlet and statues of Peggy made the obscure legend widely known. Through his artistic use of this legend, the story in a way has become deGarthe's own.
2. Edith Hamilton, *Mythology* (New York: New American Library, 1969), p. 32.
3. Ernest Hemingway, *The Old Man and the Sea* (New York: Charles Scribner's Sons, 1980), p. 30.
4. From the legend of the Holy Grail as quoted in Joseph Campbell, *Creative Mythology* (New York: Penguin Books, 1976), pp. 36-37.

Chapter 5

1. Captain Joshua Slocum, *Sailing Alone Around the World and Voyage of the Liberdade* (London, England: Hazel, Watson and Viney Ltd., 1949), p. 31.
2. *The Rime of the Ancient Mariner,* lines 105, 106.
3. Herman Melville, *Moby Dick* (New York, Peebles Press), p. 5.
4. The theme of working men being closer to the natural world than other men and thus to the secrets of a unified world was propounded throughout the 19th century and received

perhaps its greatest expression in the paintings and writings of Dutch artist, Vincent Van Gogh. This tormented genius wrote in a letter to his brother: "And I am sick of the *boredom* of civilization. It *is* better, one *is* happier if one carries it out — [living the life of peasants among peasants] — one feels at least that one is really alive. And it is a good thing in winter to be deep in the snow, in the autumn deep in the yellow leaves, in summer among the ripe corn, in spring amid the grass; it is a good thing to be always with the mowers and the peasant girls, in summer with a big sky overhead, in winter by the fireside, and to feel that it always has been and always will be so. — *The Letters of Vincent Van Gogh* (Glasgow: William Collins, Sons & Co. Ltd., 1979), p. 229.

Chapter 6

1. deGarthe asked that the monument not be completed after his death. This wish was respected with one exception. In 1984 Agnes asked Donald Crooks to carve in the dory that the men are hauling, a missing detail that spoiled the overall effect. Donald did so unassisted. The stone has since been cleaned by sand blasting and sprayed with a mixture of silicone and a touch of white paint to preserve the surface from the elements and provide a light reflective covering.

Chapter 7

1. The great Russian writer Dostoevsky expressed this concept in an early newspaper column called "the Petersburg Feuilletons," as quoted in Joseph Frank, *Dostoevsky, The Seeds of Revolt, 1821-1849* (Princeton, New Jersey: Princeton University Press, 1976), p. 232.

2. This was in 1977. The estimated value would rise with the years. I used the lowest figure quoted in the *Chronicle-Herald*. A professional appraiser had been approached by deGarthe, but never made an evaluation. The figure of $140,000 probably came from deGarthe, based on his current prices. At an average price of $5,600 per canvas, the estimate is certainly not exaggerated.

3. From a conversation with my sister, whose own expression for Diana was "the protectress of inviolable boundaries."

Chronology of the life of William deGarthe

1907
Born April 14 at Kaskö, Finland.

1917
Finland declares her independence in the wake of the Russian Revolution.

1918
Finnish Civil War between the "Whites" and the "Reds" to determine the political future of the country. The "Whites" or Finnish nationalists win.

1919
Finland engages in war with Russia. Peace is settled with no boundary changes.

1925
Finishes high school. Starts compulsory military service. Trains at the Military Academy in Hamina,

Finland, where he studies engineering and map making. He briefly studies art at Helsinki.

1926
Leaves Finland on September 22 and arrives in Halifax on October 3rd. Moves on to North Bay and McLellan where he begins working in the woods. He quits this work and arrives in Montreal on December 7th. Various odd jobs.

1927
Gets a job as an illustrator with the Dodd Simpson Press. Visited by his brother Mauritz, a former sailor, who moves on to the prairies. Takes first art lessons with Edward Dyonette at the Museum of Fine Arts.

1930
Quits job in Montreal. Passes through Halifax on his

way to visit an aunt in Brazil, but while in Halifax, he accepts a job with Wallace Advertising. He works with this agency for the next 15 years.

1931
He sees Peggy's Cove for the first time.

1934
Granted Canadian Citizenship.

1935
Marriage to Phoebe Agnes Payne.

1936
Moves to Purcell's Cove. He becomes friends with members of the Armdale Yacht Club, which is just establishing itself on Melville Island.

1938
The final race of the schooner *Bluenose* off

Gloucester and Boston, this is regarded by many as the closing of an era. He buys a property in Timberlea, begins building a house.

1939
As WW II starts, Russia invades Finland in "the Winter War". deGarthe wants to return to Finland to join the defenders, his father convinces him to stay in Canada.

1940
Begins painting with the encouragement of war artist, Leonard Brooks. In the next few years, he studies at Mount Allison University in Sackville, New Brunswick, under Stanley Royle, at the Art Students' League in New York and takes marine painting courses in Gloucester and Rockport.

1942-50
Teaches a class in commercial art to students of the Nova Scotia College of Art.

1945
Starts his own advertising business which he runs with his wife for the next ten years.

1948
Buys a cottage in Peggy's Cove. Visits on weekends and every free moment. He becomes active with association of local artists and exhibits frequently.

1949
Joins his friend Ron Wallace in promoting the "nation" of Outer Baldonia. It is an elaborate practical joke, receiving international press attention. The Imperial Bank of Commerce buy a painting and reproduce it on a nationally distributed calendar.

1951
First deGarthe painting to appear on the cover of the annual report of Nova Scotia Light and Power. He

broadcasts a radio lecture over CBA and CBH in Halifax on the theme "Painting as a Pastime." He is approached by the YMCA to conduct an art class. The class is a success and continues for the next five years.

1952
Travels through Europe before returning to Finland for the Olympic Games and to visit his family. It is his first visit back since leaving.

1955
Permanent move to Peggy's Cove. He opens a studio and gallery and becomes a full-time artist. The Art Gallery of Nova Scotia acquire *After the Hurricane*.

1956
Writes and publishes *This is Peggy's Cove*, which is currently in its 21st printing.

1956-58
Teaches commercial art at Nova Scotia College of Art.

1956-59
Spends winters in Barbados and has a one-man show there.

1958
Participates in a group show held at the Provincial Archives, celebrating the Nova Scotia Museum of Fine Arts' 50th anniversary. He is chairman of a planning committee, whose goal is to find a space for a new art gallery. He holds a one-man show at the Halifax Public Library.

1959
One-man show in Montreal.

1960
Travels in Portugal and Spain.

1961
Studies "Life class painting" in Rome, Italy. Studies at the Academy Julien and at the Academie de la Grand Chaumieire in Paris, France.

1962
Spends winter in Florida. Takes up sculpturing under the guidance of Leslie Posey in Longboat Key, Florida.

1963
Donates two murals to the church in Peggy's Cove. His studio is destroyed in Hurricane Ginny. He sets up in a new building across the street next year.

1964
One-man show in Toronto at Studio Showcase Limited.

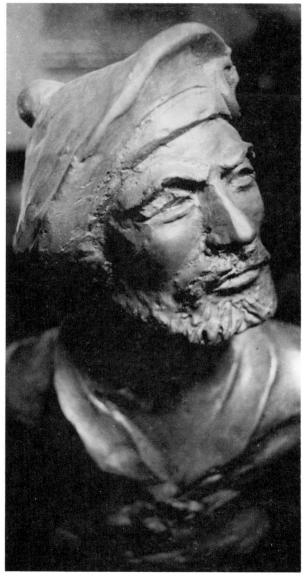

1965
Travels to London, England where he exhibits under the Royal Society of Marine Painters.

1967
Visits Expo in Montreal with his brother Gosta Degerstedt and nephew Tom.

1968
Donates a painting to his hometown, Kaskö, Finland, the port from which his brother Mauritz sailed in his youth. Travels to Finland to take part in a special ceremony.

1969
Writes and publishes *Painting the Sea,* an instruction book for marine painters. He holds a one-man show at the Citadel in Halifax called "The Men of the Sea".

1970
Paints *Out of the Mist;* he considers this his best painting and will never sell it.

1972
Trip to Africa.

1974
Trip to the Galapagos Islands.

1975
Trip to Rio de Janeiro.

1976
Studies sculpturing in marble at Pietrasanta, near Florence, Italy. He studies here for three winters, producing studies of Peggy and of the Fisherman's Family, both of which will feature prominently in the Fishermen's Monument.

1977
Starts sculpturing the Fishermen's Monument on the

100 foot long granite wall in his backyard. For the fun of it, he writes and publishes *The Story of the Herring Gull;* illustrated with many cartoons, it becomes very popular with tourists. He gives a painting workshop to the wives and delegates of a National Premiers' Conference held at Digby Pines, Nova Scotia.

He donates 25 paintings valued at one hundred and forty thousand dollars to the government of Nova Scotia. They will be housed in Government House on a temporary basis.

1979

Suffers heart attack in Florida. He is brought to Halifax, where he spends four weeks in hospital.

1982

Diagnosed as having cancer.

1983

He dies on February 13, in a hospital in Toronto. He was 75. A funeral service is held in Peggy's Cove. His ashes are deposited in a vault inside the Fishermen's Monument according to his wishes. His gift of the 25 paintings are moved from Government House to a permanent home in the Provincial Archives of Nova Scotia. René Barrette writes and publishes *William E. deGarthe's Great Monument of Peggy's Cove,* a small book explaining the concept and development of the monument.

1985

The Fishermen's Monument is donated to the Government of Nova Scotia. It is made into a provincial park and a plaque is erected to honour William deGarthe.

Detail of a painting, 1968.
Collection of the Royal Bank of Canada.